RAILROADS OF WISCONSIN

Mike Danneman

AMBERLEY

First published 2022

Amberley Publishing
The Hill, Stroud
Gloucestershire, GL5 4EP

www.amberley-books.com

Copyright © Mike Danneman, 2022

The right of Mike Danneman to be identified
as the Author of this work has been asserted in
accordance with the Copyrights, Designs and
Patents Act 1988.

ISBN 978 1 3981 0317 7 (print)
ISBN 978 1 3981 0318 4 (ebook)

British Library Cataloguing in Publication Data.
A catalogue record for this book is available from
the British Library.

Typesetting by SJmagic DESIGN SERVICES, India.
Printed in the UK.

Introduction

Wisconsin, known as the 'Badger State', is located in the upper midwest of the United States, bordered by Lake Michigan on the east and Mississippi River to the west, with a port on Lake Superior in the far north. Much of Wisconsin's topography was greatly influenced by glaciers during the Ice Age, and has been the home to a wide variety of cultures for the past 14,000 years.

The first European to arrive in what became Wisconsin was likely French explorer Jean Nicolet in 1634, and other explorers soon followed. Wisconsin's oldest settlement, Green Bay, began as a trading post in 1745. The area remained under French control until 1763, when it was acquired by the British, and was subsequently ceded to the United States in 1783.

Americans on the move quickly settled the land, clearing trees for farming, building roads, houses and new towns. Immigrants from northern Europe began arriving by the 1830s and the population continued to grow. Wisconsin became the thirtieth state in the union in 1848, a year after the first railroad was chartered to connect Milwaukee and Waukesha. The first train ran over this route on 25 February 1851, on what later became the Chicago, Milwaukee, St Paul & Pacific Railroad, more commonly called the Milwaukee Road. The railroad pushed on and was completed from the shore of Lake Michigan to the Mississippi River by 1857. Not long after, other railroads began criss-crossing the state, allowing farms and growing manufacturing industries to ship their products to other parts of the country.

By 1860, there were nearly 200 breweries in Wisconsin, with more than forty in the Milwaukee area. Many of them relied extensively on railroads for raw materials and ingredients, and shipment of beer to thirsty consumers. Dairy farming also became popular in the state, meshing perfectly with many immigrants from Europe that brought an extensive knowledge of cheesemaking. By 1899, over ninety per cent of Wisconsin farms raised dairy cows and by 1915, Wisconsin had become the leading producer of dairy products in the United States. Northern Wisconsin also saw extensive logging. Construction of railroads allowed logging year round, after rivers froze, and the ability go deeper into virgin forests. Logging expanded industries fabricating wood products in many cities, providing railroads with more tonnage to move. Later, a growing paper industry in the Fox River Valley took advantage of wood pulp from the state's logging operations.

Railroads in Wisconsin built a network of main lines, secondary lines and branch lines serving farmland and rural communities, as well as connecting cities like Milwaukee and Minneapolis/St Paul, and by 1920, route-miles peaked at a little over 7,500. The three largest railroads in Wisconsin were the Chicago & North Western,

Milwaukee Road and Soo Line. North Western was the state's dominate railroad that seemingly went everywhere. Milwaukee Road covered the southern part of the state, while Soo Line blanketed the northern portion. All three had many low-density branches, and all three were operating under court-appointed trustees in 1940 – not a good combination. An over-built railroad network in the state saw an inevitable decline in route miles, and this contraction really began accelerating in the 1960s.

Milwaukee Road's 1977 bankruptcy triggered some interesting changes in the Wisconsin railroad scene. In a bidding war with Grand Truck Western (an American subsidiary of Canadian National), Soo Line (an American subsidiary of Canadian Pacific) overextended itself buying the Milwaukee Road in 1985. As part of the purchase, it also was ordered to divest some of its routes in the interest of preserving competition. As a result, it created Lakes States Transportation Division, and soon sold off its historic Wisconsin trackage to the newly formed Wisconsin Central in 1987. CN ended up purchasing WC in 2001, allowing it to claim just under fifty per cent of all rail mileage in the state, while the former Milwaukee Road main line linking Chicago and St Paul has ironically become a key link in CP's system.

Meanwhile, Chicago & North Western had a decades-long practice of abandoning or spinning off Wisconsin lines. C&NW had more than 2,500 miles in 1940, while by 2005 successor Union Pacific operated just 650 Wisconsin route-miles. The Chicago, Burlington & Quincy line along the Mississippi River should not be forgotten either; a once passenger-heavy route in 1940, it is the state's most heavily used all-freight main line in the Burlington Northern/BNSF era.

With all the pruning of Wisconsin's railroad milage, the state itself has stepped in, preserving about 625 miles of previously abandoned rail lines that now operate as short line and regional freight railroads. By 2007, there were just over 3,400 miles of rail lines in Wisconsin.

Growing up and spending a portion of my adult life in Wisconsin, I enjoyed many years photographing the railroads of the state. My initial photographic efforts are like many endeavors early on – still on a learning curve. All photos in this book were taken by myself from 1979 to 2005. I decided to organise them in chronological order, since many subjects closer to home received more attention than others, and some places farther away remained unexplored. Locations like northern Wisconsin have many routes that are lightly used, so they always ended up on a 'to do' list. Regardless, I hope this variety of imagery seen on the following pages will give you an enjoyable look at the ever-changing and fascinating railroads of Wisconsin.

Railroads of Wisconsin—1990

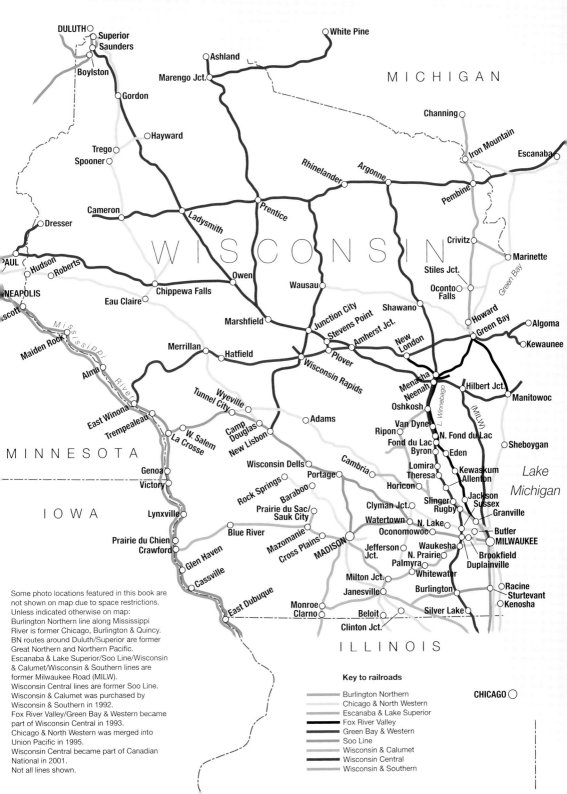

Lake Superior

MICHIGAN

WISCONSIN

MINNESOTA

IOWA

ILLINOIS

Lake Michigan

Mississippi River

L. Winnebago

Green Bay

DULUTH
Superior
Saunders
Boylston
Gordon
Hayward
Trego
Spooner
Cameron
Dresser
PAUL
Hudson
Roberts
NEAPOLIS
scott
Maiden Rock
Alma
East Winona
Trempealeau
La Crosse
W. Salem
Genoa
Victory
Lynxville
Prairie du Chien
Crawford
Glen Haven
Cassville
East Dubuque

Ashland
Marengo Jct.
White Pine
Channing
Iron Mountain
Escanaba
Rhinelander
Argonne
Pembine
Ladysmith
Prentice
Crivitz
Marinette
Owen
Wausau
Stiles Jct.
Oconto Falls
Howard
Green Bay
Algoma
Kewaunee
Chippewa Falls
Eau Claire
Marshfield
Junction City
Stevens Point
Shawano
Merrillan
Hatfield
Plover
Wisconsin Rapids
Amherst Jct.
New London
Menasha
Neenah
Hilbert Jct.
Manitowoc
Wyeville
Tunnel City
Camp Douglas
New Lisbon
Adams
Oshkosh
Van Dyne
Ripon
Fond du Lac
N. Fond du Lac
Sheboygan
Byron
Eden
Wisconsin Dells
Portage
Cambria
Lomira
Theresa
Kewaskum
Allenton
Rock Springs
Baraboo
Horicon
Jackson
Sussex
Granville
Prairie du Sac/Sauk City
Clyman Jct.
Slinger
Rugby
Blue River
Watertown
N. Lake
Oconomowoc
Butler
MILWAUKEE
Mazomanie
Cross Plains
MADISON
Jefferson Jct.
Waukesha
N. Prairie
Brookfield
Duplainville
Palmyra
Whitewater
Milton Jct.
Janesville
Burlington
Racine
Sturtevant
Kenosha
Monroe
Clarno
Beloit
Silver Lake
Clinton Jct.

(MILW)

Green Bay

Some photo locations featured in this book are
not shown on map due to space restrictions.
Unless indicated otherwise on map:
Burlington Northern line along Mississippi
River is former Chicago, Burlington & Quincy.
BN routes around Duluth/Superior are former
Great Northern and Northern Pacific.
Escanaba & Lake Superior/Soo Line/Wisconsin
& Calumet/Wisconsin & Southern lines are
former Milwaukee Road (MILW).
Wisconsin Central lines are former Soo Line.
Wisconsin & Calumet was purchased by
Wisconsin & Southern in 1992.
Fox River Valley/Green Bay & Western became
part of Wisconsin Central in 1993.
Chicago & North Western was merged into
Union Pacific in 1995.
Wisconsin Central became part of Canadian
National in 2001.
Not all lines shown.

Key to railroads

CHICAGO

Burlington Northern
Chicago & North Western
Escanaba & Lake Superior
Fox River Valley
Green Bay & Western
Soo Line
Wisconsin & Calumet
Wisconsin Central
Wisconsin & Southern

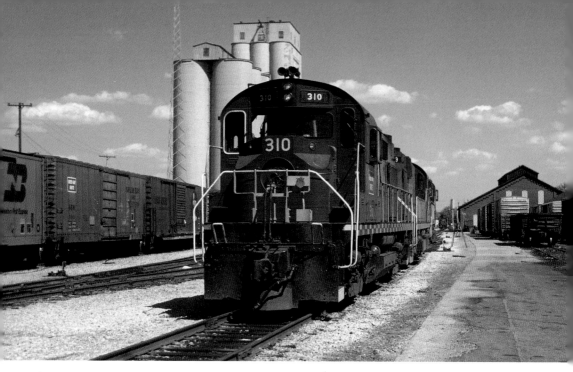

Green Bay & Western Alco RS27 No. 310 is on the west end of the locomotive set for train 1 at Green Bay, Wisconsin. This is one of my very first 35-mm railroad photos, taken in June 1979, when I was a fifteen-year-old and just beginning to get serious about the photography hobby.

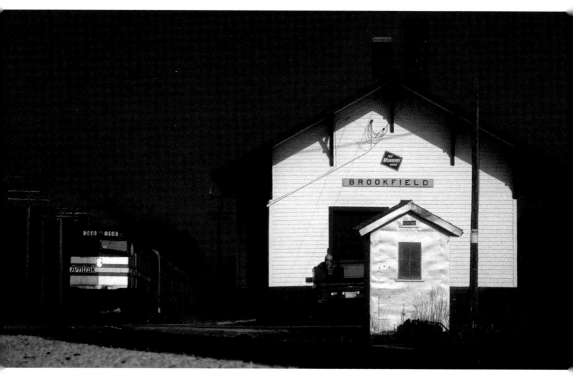

Under a dark, stormy sky, Amtrak's westbound Empire Builder is about to pass Milwaukee Road's 1867 train station at Brookfield in April 1983.

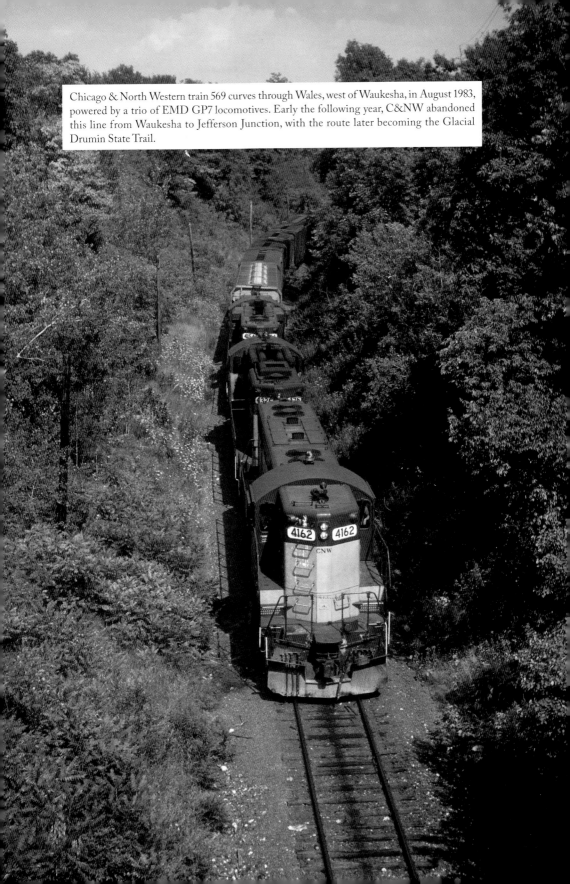

Chicago & North Western train 569 curves through Wales, west of Waukesha, in August 1983, powered by a trio of EMD GP7 locomotives. Early the following year, C&NW abandoned this line from Waukesha to Jefferson Junction, with the route later becoming the Glacial Drumin State Trail.

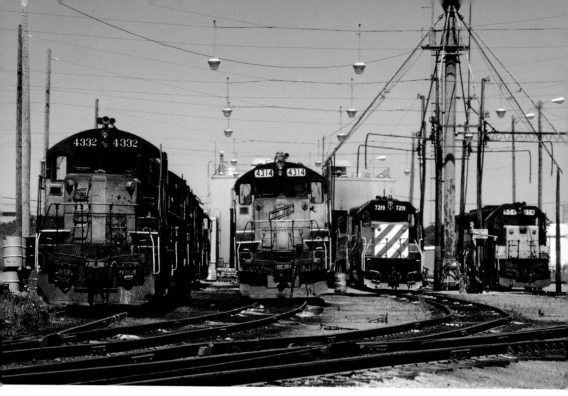

The tracks are full at Chicago & North Western's Butler Yard enginehouse at Butler in August 1983. A large group of GP7s, very common in this area at the time, occupy the tracks on the left, while a set of run-through Burlington Northern power off a coal train and a set of road locomotives led by SD45 No. 954 are under the sand tower.

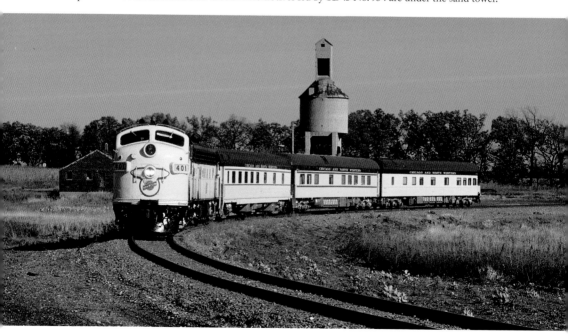

A Chicago & North Western inspection train curves out of Clyman Junction in October 1983. C&NW just rebuilt this line from Clyman Junction through Watertown to serve Ladish Malts at Jefferson Junction with this connection to the Adams Line. This ultimately led to the abandonment of the C&NW line from Waukesha to Jefferson Junction.

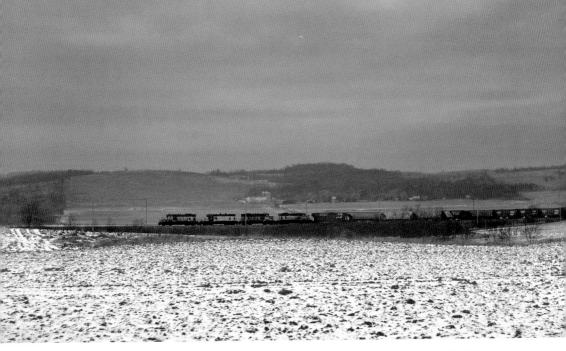

The skies are leaden and scenery umber, with many shades between fading to the horizon. A skiff of snow over harvested fields brightens the scene, but chilly winds from the north ushering in more dampness lets you know it is December in Wisconsin. Just west of Waukesha, Chicago & North Western's train 569, a freight between Butler Yard and Jefferson Junction, heads for Wales through the bleak countryside in December 1983. Four GP7s led by 4319 fill the winter air with the chant of EMD's enduring 567.

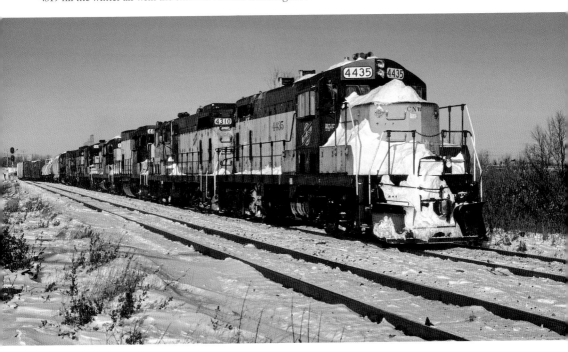

Chicago & North Western's train from Green Bay enters Butler Yard after encountering some snow on the trip south in December 1983. Powering the train are five EMD GP7s, an EMD GP15-1 and a big Alco C628 bringing up the rear.

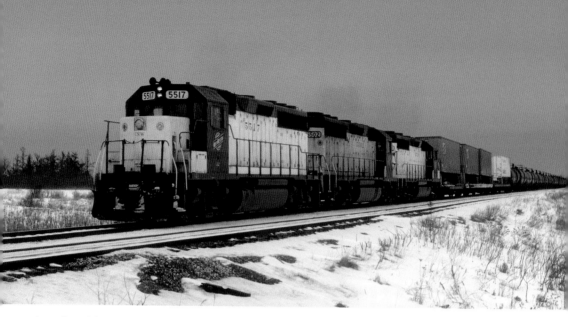

A westbound Chicago & North Western freight approaches the Marcy Road grade crossing at Menomonee Falls, a western suburb of Milwaukee, in January 1984. The train is powered by a trio of former Conrail GP40s now painted in C&NW's 'Zito yellow' paint scheme, named after Senior Vice President of Operation of C&NW, James A. Zito.

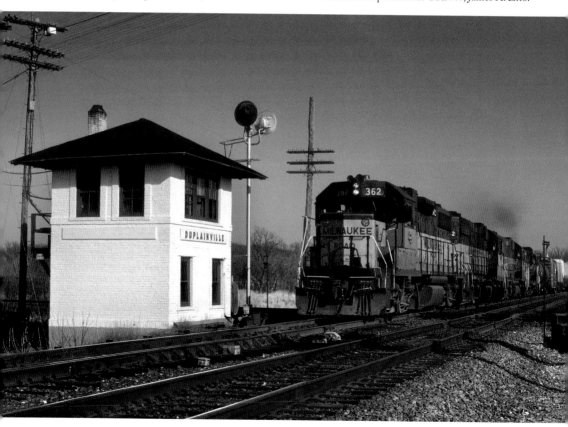

A westbound Milwaukee Road freight crosses the Soo Line diamonds, rattling the windows of Duplainville tower on a snowless Wisconsin winter day in February 1984.

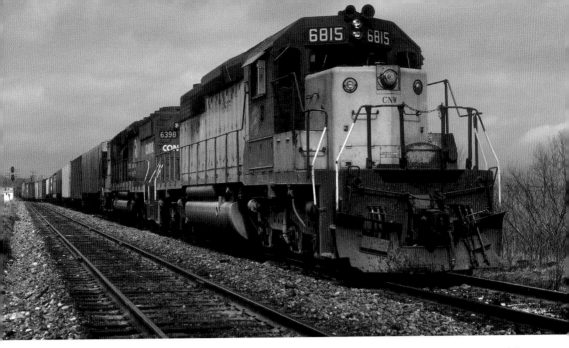

In February 1984, a Chicago & North Western freight enters Butler Yard after an eastbound trip across the Adams Line. Powering the train is a pair of EMD SD40-2s, with C&NW No. 6815 leading Conrail No. 6398.

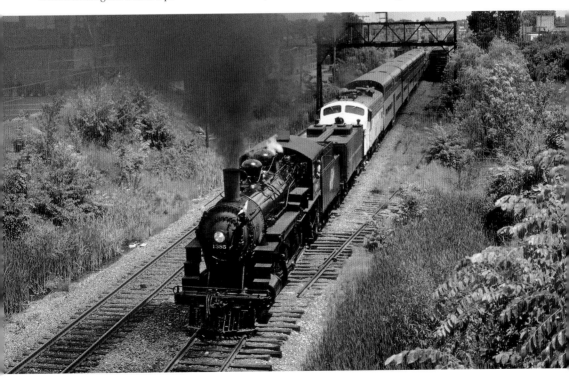

Chicago & North Western 4-6-0 No. 1385 powers a 'Butler Railroad Days' passenger extra at West Allis in June 1984. The train consists of No. 1385, protected by EMD F7A No. 402, pulling four bi-level coaches borrowed from Chicago commuter service and a couple of business cars on the rear. In this view, the train is headed back to Butler westbound on the Belt Line around Milwaukee as seen from the 92nd Street overpass.

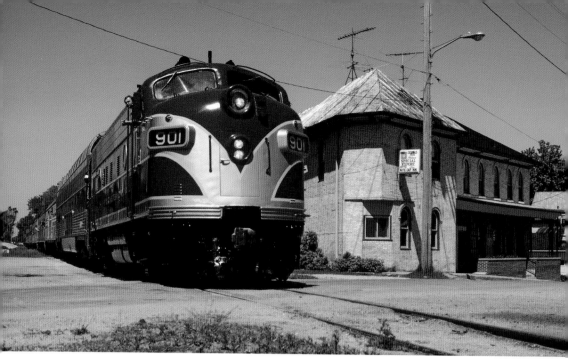

In June 1984, Golden Arrow Lines (train tour operator) ran excursions on the Central Wisconsin Railroad route between Waukesha and Whitewater. Passing the Nite Cap Inn at Palmyra is one of the eastbound excursions led by Charleston & Western Carolina EMD F7 No. 901. This particular line became part of Wisconsin & Calumet (WICT) the following year, and will later be part of the Wisconsin & Southern system.

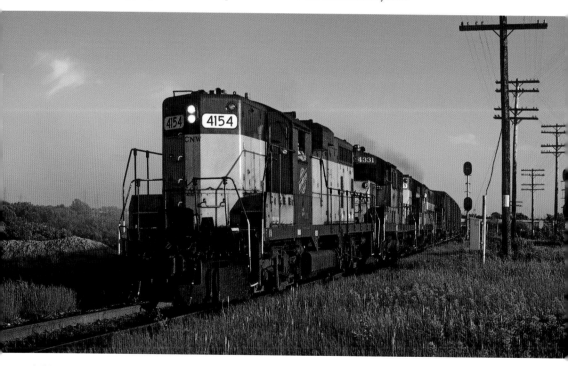

A Chicago & North Western freight headed for Green Bay leaves Butler Yard on a June 1984 afternoon. The train is powered by a quartet of C&NW's venerable EMD GP7s.

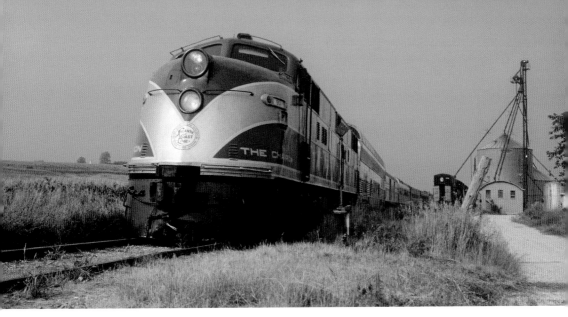

A Golden Arrow Lines excursion on the Central Wisconsin Railroad route between Waukesha and North Prairie is passing a small grain elevator off Main Street east of Genesee Depot in August 1984. It is passing some stored former Milwaukee Road Fairbanks-Morse H12-44 locomotives from the CWRC operation. These will later be scrapped. This line became part of Wisconsin & Calumet (WICT) the next year, and will later be part of the Wisconsin & Southern. Glen Monhart's classy purple and silver Atlantic Coast Line EMD E3 No. 501 is powering the westbound train. He also owned and painted a former Rio Grande F7 in the same matching colors for Charleston & Western Carolina, to operate with his E3.

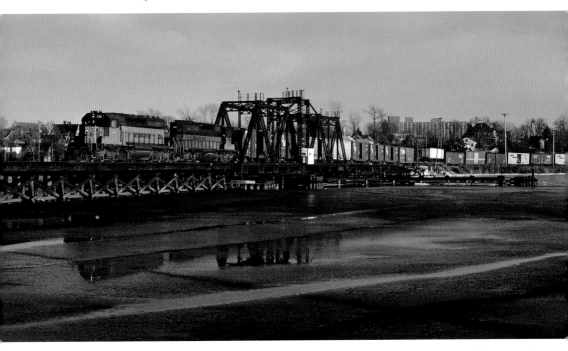

Milwaukee Road's Milwaukee to Green Bay freight crosses the Fox River at Green Bay in December 1984, and will soon be arriving at the railroad's yard just off Ashland Avenue where it will tie up. After 1980, Milwaukee Road lines north of Green Bay to Ontonagon and Channing, Michigan, were sold to Escanaba & Lake Superior Railroad.

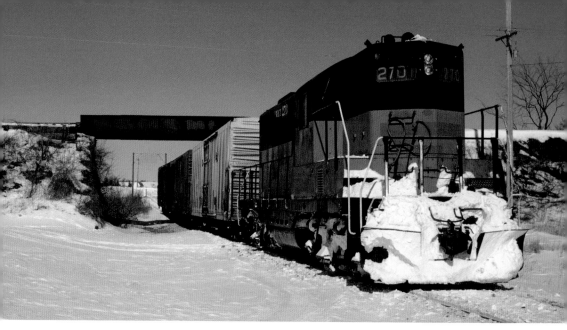

A Wisconsin & Calumet three-car freight departs Monroe over a snow-covered former Illinois Central Gulf branch line running between Madison, Wisconsin, and Freeport, Illinois, on 17 February 1985. Former Milwaukee Road EMD GP9 No. 270 powers the train, and ironically, passes under the bridge carrying the former Milwaukee Road branch to Platteville and Mineral Point. Believe it or not, and perfectly following Wisconsin traditions, the three cars contain Huber Beer and Swiss Colony Cheese from Monroe!

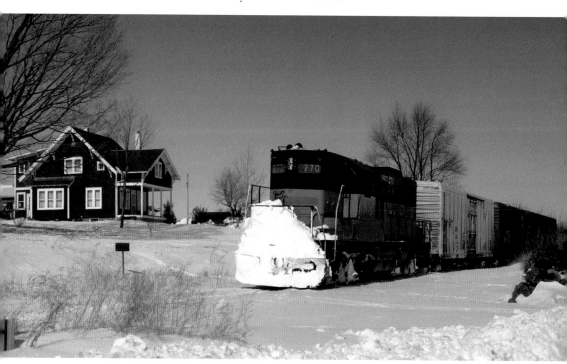

Wisconsin & Calumet GP9 No. 270 and its diminutive train approaches the Illinois state line as it slowly curves through Clarno on 17 February 1985. This little-used line from Madison to Freeport was eventually torn up in late 1999 and turned into a recreational trail.

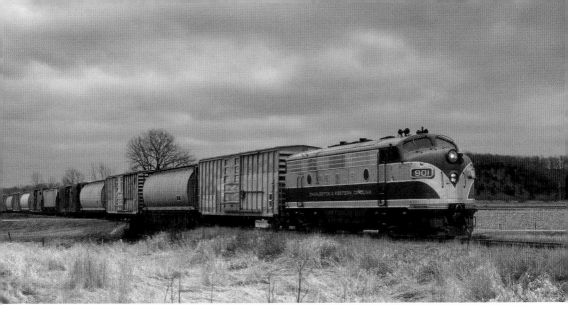

On a typically gloomy spring day in Wisconsin on 30 March 1985, Charleston & Western Carolina EMD F7 No. 901 does some freight duties during car clean up at the end of operations for short line Wisconsin Western. The westbound train is crossing Black Earth Creek west of Cross Plains on this former Milwaukee Road line from Madison, west to Prairie du Chien. On this day, it will make a trip to Mazomanie and a run up the branch to Prairie du Sac-Sauk City, before heading back to Madison. C&WC No. 901 is the former Rio Grande No. 5644 that also served American Crystal Sugar Co. and Chicago, Madison & Northern before adorning purple and silver paint as Charleston & Western Carolina No. 901. Former Toledo, Peoria & Western caboose No. 529 trails on the fifteen-car train.

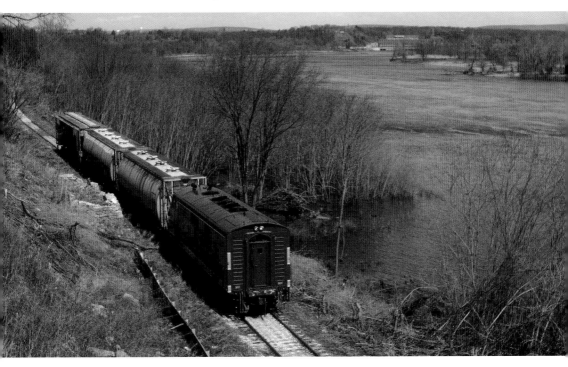

Striking a unique pose, Charleston & Western Carolina No. 901 operates backwards while retrieving three cars off the Prairie du Sac-Sauk City branch on 6 April 1985. In this view, the train is slowly rolling along the Wisconsin River at Prairie du Sac.

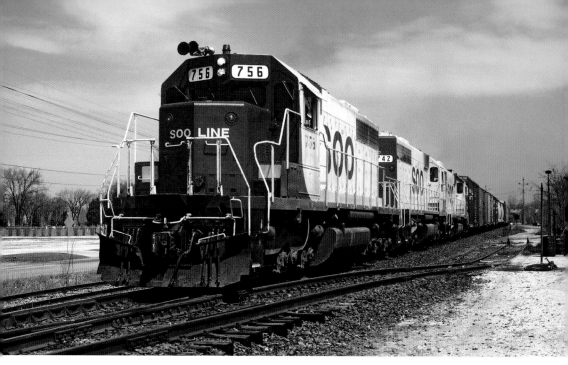

A Soo Line freight heads south through Waukesha on 20 April 1985. Two EMD SD40s and a GP38-2 take the train across West Avenue and toward the train's final destination of Schiller Park yard outside Chicago.

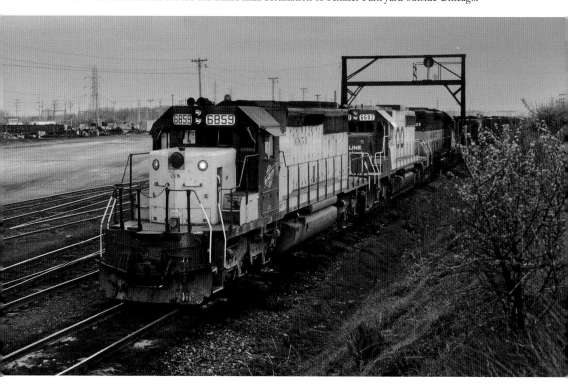

Changing crews at Butler Yard late in the afternoon of 20 April 1985 is a westbound Chicago & North Western coal train. It is the first time I saw locomotives from all three of Wisconsin's major railroads powering a train together. The trio are all EMD SD40-2 locomotives, with C&NW No. 6859 leading Soo Line No. 6602 and Milwaukee Road No. 28.

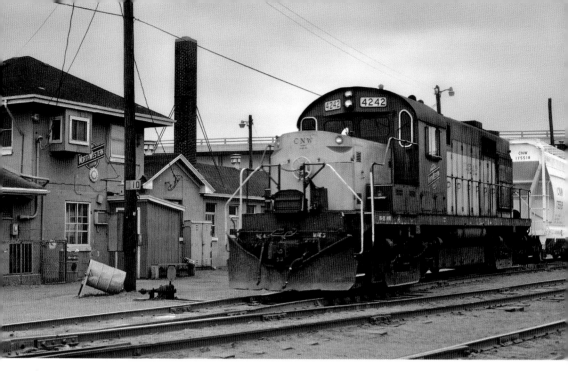

A Chicago & North Western Alco RS32 switches cars in front of the yard office at Green Bay on 27 April 1985. During this era, Green Bay was a haven for Alco locomotive enthusiasts.

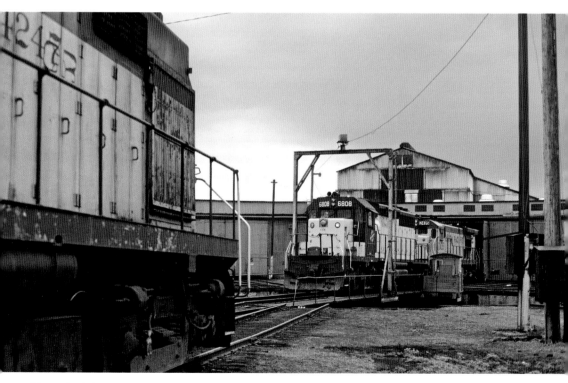

Having hauled a coal train north out of Butler Yard earlier that morning, Chicago & North Western EMD SD40-2 No. 6808 backs one of the trailing Union Pacific GE C30-7s into the roundhouse at Green Bay on 27 April 1985. Sitting on one of the radial tracks to the left is C&NW No. 4247, a former Conrail Alco RS32 bought on the used market by C&NW.

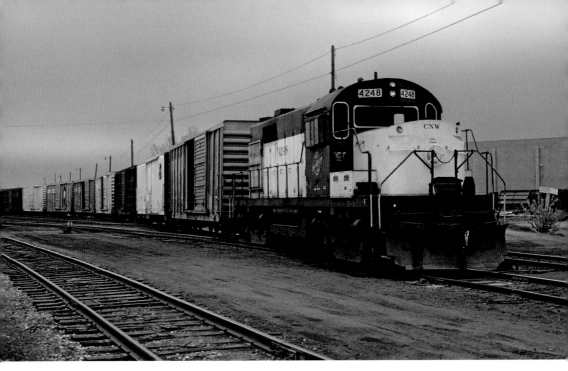

Originally an Alco built in 1962 for New York Central, Chicago & North Western, RS32 No. 4248 is now decked out in Zito yellow as it switches at Green Bay on 27 April 1985.

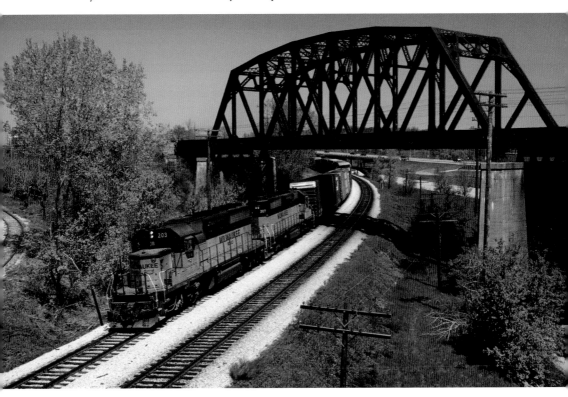

Milwaukee Road westbound hotshot train 203, coincidentally led by EMD SD40-2 No. 203, rumbles underneath the Chicago & North Western truss bridge at Wauwatosa in suburban Milwaukee on 28 April 1985.

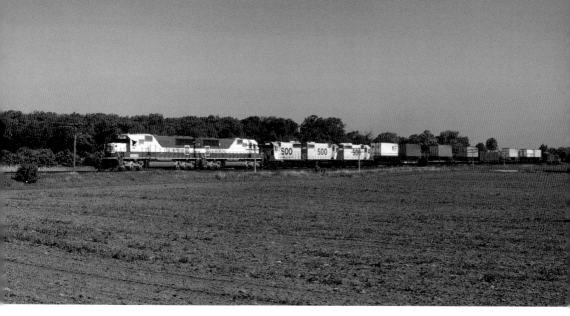

On 25 May 1985, Soo Line tested Electro-Motive Division's brand new SD60 demonstrators on a train south out of Shops yard at North Fond du Lac. A train of 111 loads and four empties, weighing in at 12,743 tons, climbed Byron Hill without the assistance of the normal helper, powered by EMD 1 and EMD 4, along with Soo GP35 No. 727, GP38-2 No. 4401 and GP40 No. 734. They made it over the hill, and in this view are departing Byron, picking up a little speed with the Chicago-bound train. Soo Line was apparently impressed enough with the new locomotives to purchase them, with Nos 6000 to 6062 arriving on the property between 1987 and 1989, with the last five being Soo's only EMD SD60M models.

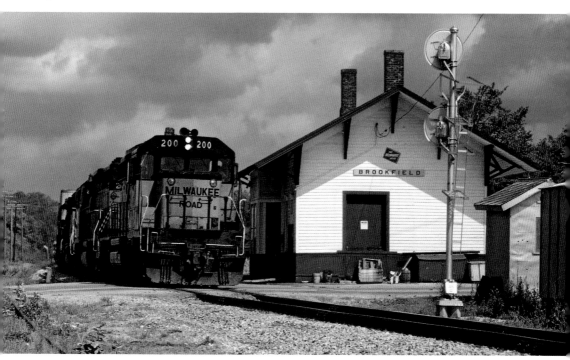

On an afternoon when the weather was a bit unpredictable, the sun pops out for a moment illuminating a westbound Milwaukee Road train passing the depot at Brookfield on 15 June 1985.

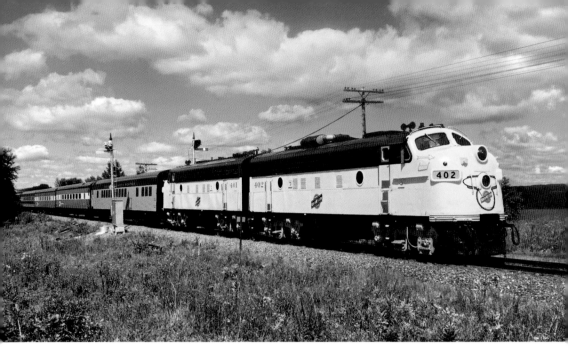

On 10 August 1985, Streamline Excursions, Inc. sponsored the 'Return of the 400', a round trip passenger excursion between Amtrak's St Paul-Minneapolis Midway Station to Eau Claire on the Chicago & North Western's main line to Milwaukee and Chicago, once the route of the famous '400'. Pulling the passenger train was C&NW F7s Nos 402 and 401, shown during a photo run by on the eastbound trip at the mile 30.7 semaphores east of Roberts.

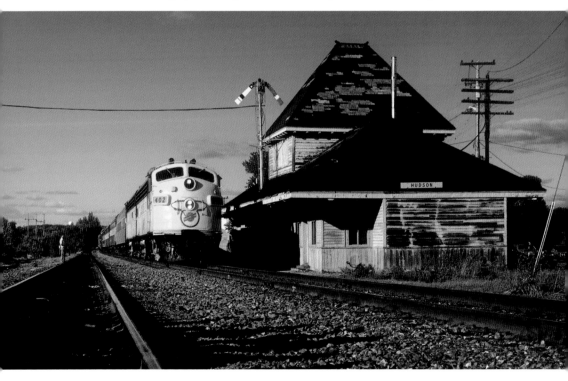

Toward the end of the day on 10 August 1985, Streamline Excursions, Inc. 'Return of the 400' passenger train is now heading back to Minneapolis/St Paul from Eau Claire and passes the old station at Hudson.

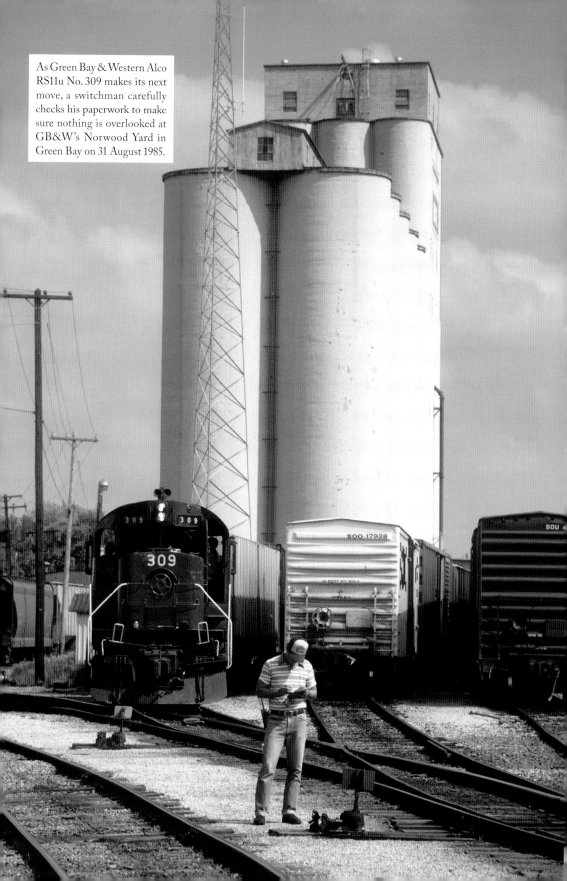

As Green Bay & Western Alco RS11u No. 309 makes its next move, a switchman carefully checks his paperwork to make sure nothing is overlooked at GB&W's Norwood Yard in Green Bay on 31 August 1985.

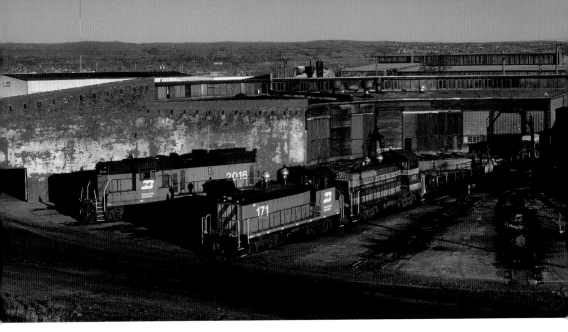

Three locomotives sit outside Burlington Northern's Belknap Street roundhouse in Superior on 19 October 1985. A couple of radial tracks off the turntable at this former Great Northern facility hosts BN EMD GP20 No. 2016, EMD SW1200 No. 171 and Lake Superior Terminal & Transfer (LST&T) EMD SW1200 No. 105 in a historical Great Northern color scheme used by the railroad.

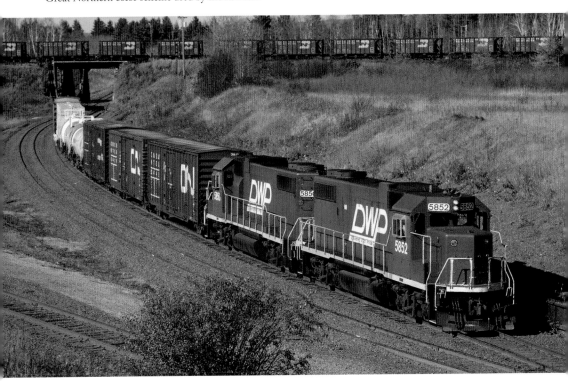

On 19 October 1985, a Duluth, Winnipeg & Pacific transfer freight bound for Chicago & North Western's Itasca Yard curves through Saunders as a Burlington Northern ore train destined for the docks at Allouez in Superior passes overhead in the background. The freshly painted DW&P EMD GP38-2s are former Rock Island locomotives.

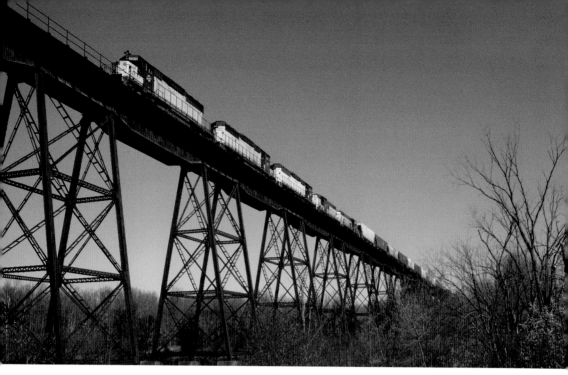

A Chicago & North Western freight is southbound on the Burlington Northern's former Great Northern bridge over the Nemadji River just south of Boylston on 19 October 1985. A trio of EMD SD40-2s and two older EMD GP7s power the southbound train on BN trackage rights to the Twin Cities (Minneapolis/St Paul).

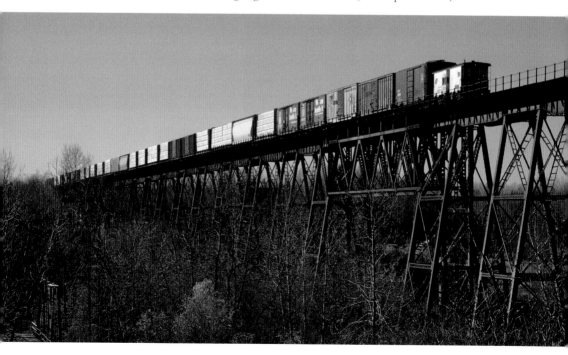

A bay-window waycar (caboose) trails a southbound Chicago & North Western freight as it crosses the lengthy Nemadji River Bridge at Boylston on 19 October 1985. This train is operating on Burlington Northern's former Great Northern Hinckley Subdivision, but BN will soon acquire and utilise Soo Line's parallel route and abandoned this bridge for Soo's Nemadji River crossing out of Boylston.

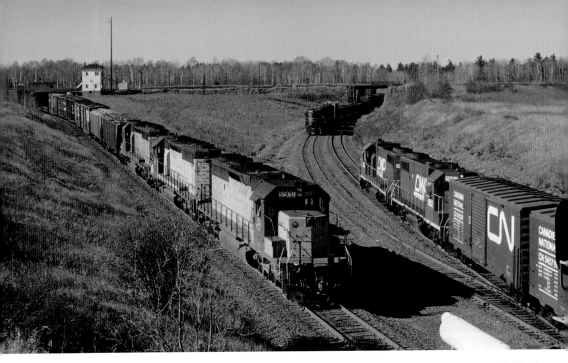

The junction at Saunders could be busy at times, like on the morning of 20 October 1985. A Chicago & North Western freight has pulled up to the signals by the Highway 35 overpass and stops. Then a Duluth, Missabe & Iron Range transfer freight pulls up and switches the siding there. It soon backs into the clear for a Duluth, Winnipeg & Pacific freight that is bound for Pokegama Yard at Superior.

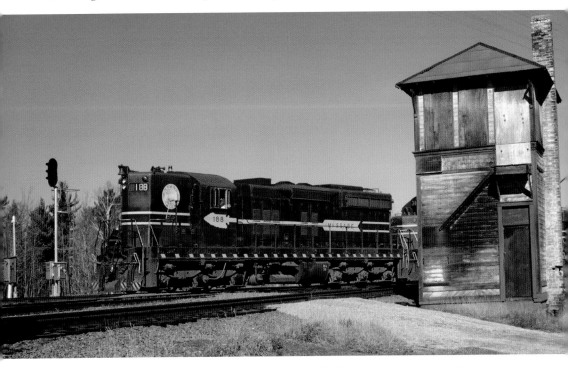

Duluth, Missabe & Iron Range's Steelton Switch, led by EMD SD18 No. 188, is returning from interchanging cars with the Soo Line at their Stinson Yard and passes retired MJ Tower on the south side of Superior on 20 October 1985.

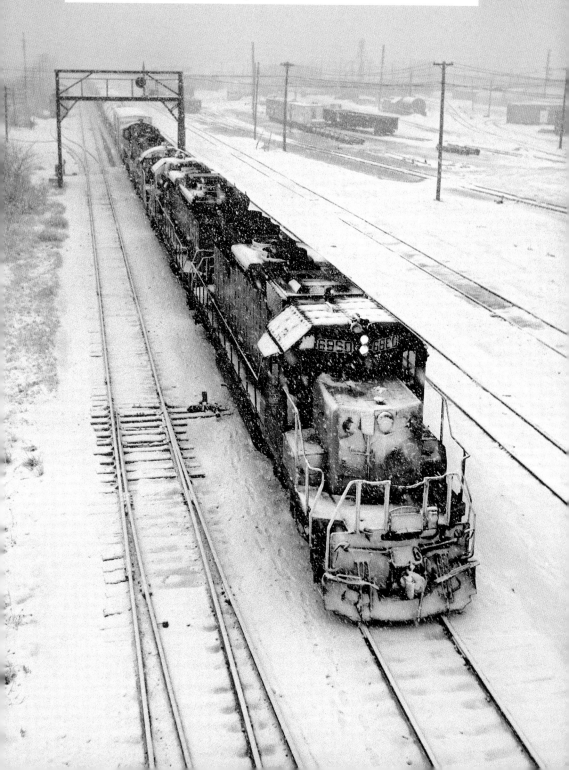

A Chicago & North Western freight arrives at the yard in Butler amid a winter flurry on 20 February 1986. C&NW EMD SD40-2 No. 6860 leads a SD45, still in former Cascade green BN colors, and a pair of GP7s for power.

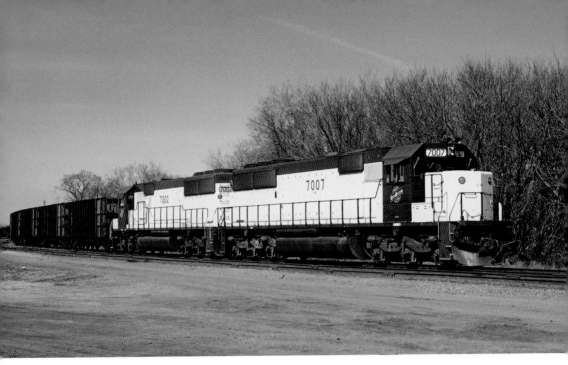

A pair of new Chicago & North Western SD50s pulling a coal train prepares to depart Butler Yard on 30 March 1986. Both were built by EMD in La Grange, Illinois, in November 1985.

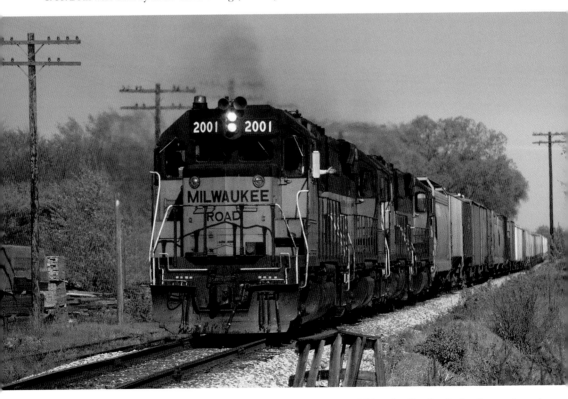

A westbound Soo Line grain train, which still looks for the world like a Milwaukee Road train, heads west through Brookfield on 4 May 1986. Officially, Soo Line Railroad merged Milwaukee Road into history on 1 January 1986.

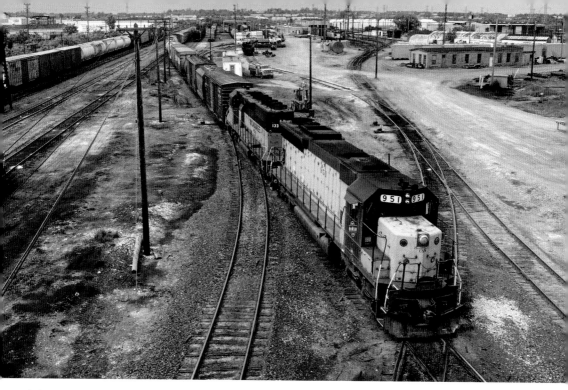

A Chicago & North Western freight enters Butler Yard, while another waits to head west on 24 May 1986. Powering the train is C&NW EMD SD45 No. 951, with Milwaukee Road EMD SD40-2 No. 133 trailing.

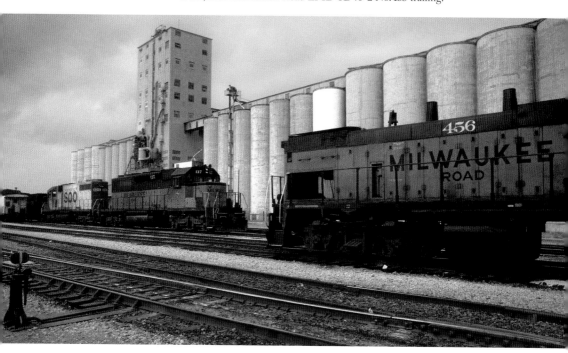

Under a backdrop of grain elevators, an eastbound freight led by Milwaukee Road EMD SD40-2 No. 137 slowly works its way through Muskego Yard in Milwaukee on 6 December 1986. After the merger a little over eleven months previous, Soo Line influence can already be seen in trailing EMD SD39 No. 6240 and red and white cars on the caboose track.

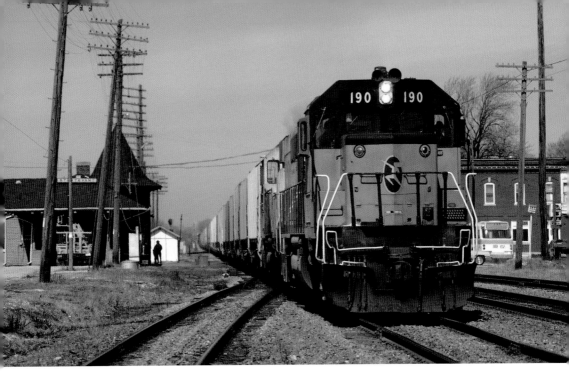

Milwaukee Road EMD SD40-2 No. 190 leads an eastbound Soo Line freight through Sturtevant on a sunny 21 March 1987. The 1901 Milwaukee Road depot on the left was still being used by Amtrak trains between Milwaukee and Chicago.

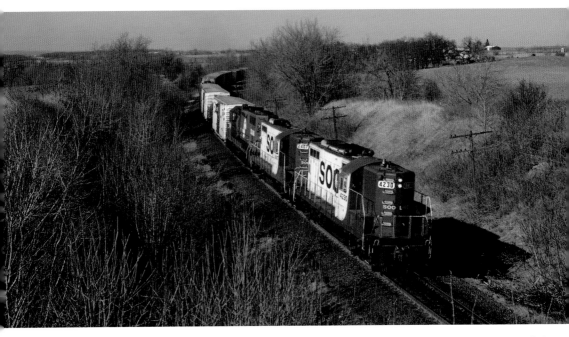

After overextending themselves acquiring Milwaukee Road, Soo Line established a wholly owned division called Lake States Transportation Division on 10 February 1986 to operate its mostly former Soo Line trackage in Wisconsin and prepare it for sale. With this move, older locomotives and some leased power began to be much more common on these lines. On 22 March 1987, a southbound Soo Line (Lake States) freight climbs Byron Hill at Byron powered by two Soo EMD GP9s and a leased Conrail EMD GP38.

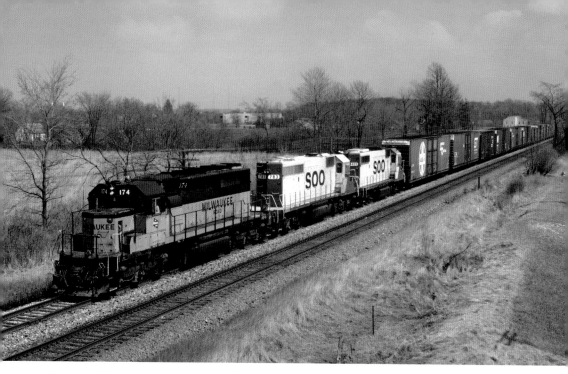

Soo Line train 203, an auto parts train to the Twin Cities, is westbound at Duplainville led by Milwaukee Road EMD SD40-2 No. 174 on 12 April 1987.

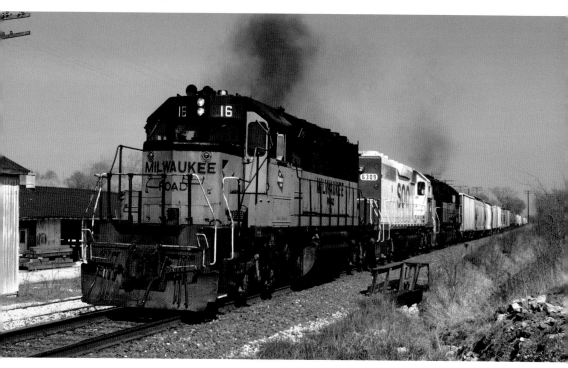

A Soo Line grain extra storms westbound through Brookfield on the afternoon of 19 April 1987. When built in July 1973, Milwaukee Road EMD No. 16 was originally numbered 177, but was renumbered when equipped as a Locotrol Master, for an early radio-control system where remote locomotives positioned back in a freight train consist could be controlled by a 'master' unit.

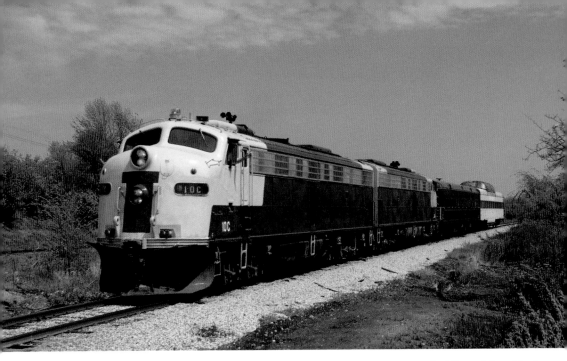

From 1987 to 1990, Wisconsin & Southern operated a luxury dinner train called 'Scenic Rail Dining' from North Milwaukee to Horicon. On 9 May 1987, WSOR EMD E9 No. 10C pulls an 'inspection train' as a precursor to the dinner train, from Granville to Horicon, seen here westbound at Germantown, located between Granville and Rugby.

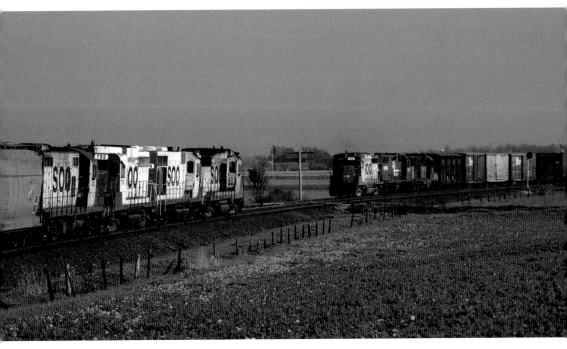

Both led by all-EMD power, Soo Line trains 12 and 17 meet at Bryon on the afternoon 9 May 1987. The Lake States era of Soo Line was colorful and frequently featured older locomotives. Powering train 12 is GP30 No. 717, GP35 No. 724, GP30 No. 700 and GP9 No. 410. Leading train 17 is another GP30, No. 712, along with leased Conrail GP38 No. 7739 and former Milwaukee Road GP20 (a rebuilt GP9) No. 962.

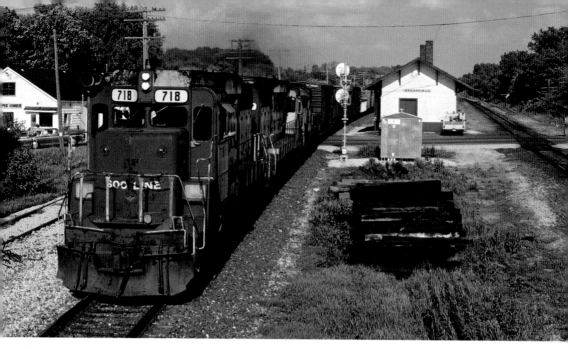

A westbound Soo Line freight train passes the Brookfield depot on the nice spring day of 26 May 1987. Power was two EMD GP30s and an EMD GP9, all of them in battle-worn paint but still nice to see. This somewhat elevated view was temporary, on top of a pile of new ties stacked between the main lines.

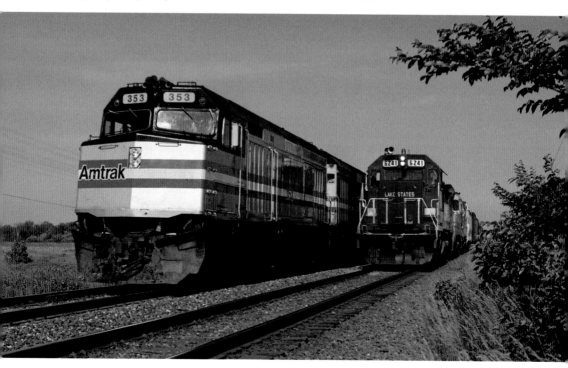

Amtrak's westbound Empire Builder passes Soo Line train 17 at Duplainville on the afternoon of 6 June 1987. Leading train 17 is a former Minneapolis, Northfield & Southern EMD SD39, as Soo acquired MN&S Nos 40 and 41 in the 1982 purchase of the railroad. Soo Line No. 6241 was the only locomotive that featured 'Lake States' lettering on its nose.

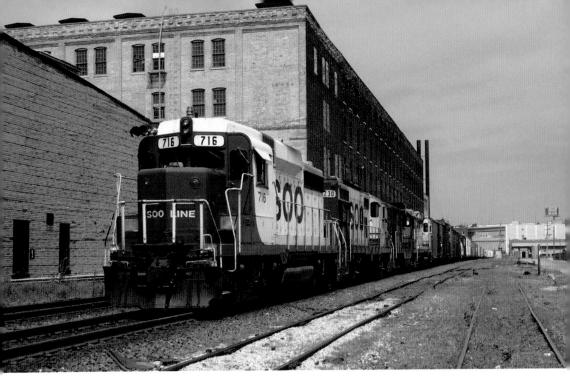

Soo Line train 17 is westbound at Milwaukee on the afternoon of 7 June 1987. The view is along Mount Vernon Avenue not far west of Milwaukee's Amtrak Station.

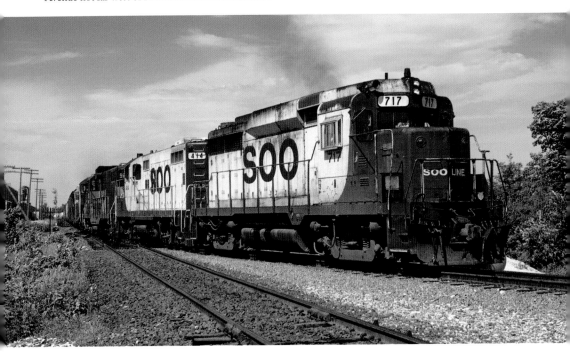

On 28 June 1987, a Soo Line freight from North Fond du Lac uses the connector track at Duplainville for a trip to Milwaukee. Leading the train is EMD GP30 No. 717, trailed by three Soo Line EMD GP9s and two former Milwaukee Road GP20s (rebuilt GP9s). The Alco AAR Type B road trucks reused from traded-in Soo Line Alco FAs can be seen under No. 717.

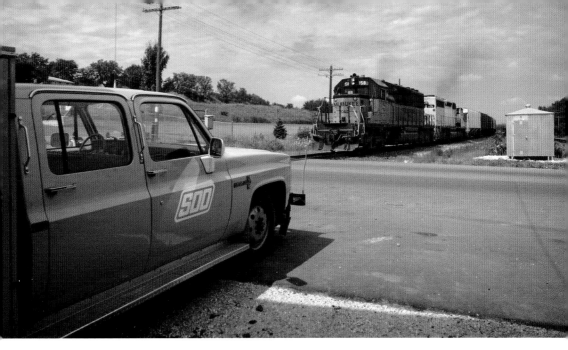

Soo Line train 12, powered by Milwaukee Road EMD SD40-2 No. 158 and former Kansas City Southern EMD SD40 No. 626, is about to roll over Brookfield Road grade crossing on 25 July 1987. The Soo Line utility truck is parked under the eve of Brookfield's revered old train depot.

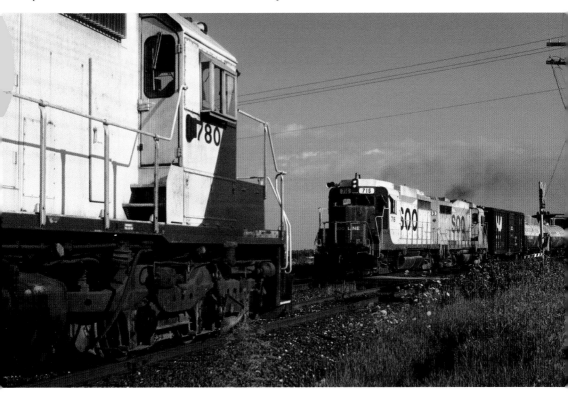

Soo Line train 11 meets train 18 at Rugby late in the afternoon of 26 July 1987. Train 11 is led by Soo EMD SD40 No. 780, while a pair of EMD GP30s built in 1963 powers train 11.

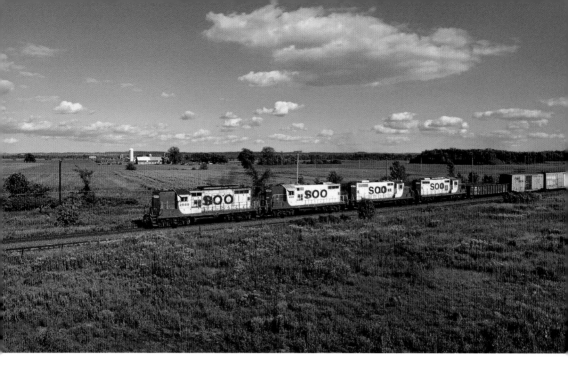

Soo Line train 19 has just left North Fond du Lac and is now cruising through farm country at Van Dyne on 23 August 1987. Power for the train is an amazing set of four EMD GP9s, Nos 2550, 400, 411 and 4231, all chanting away up the main line to Neenah as seen from the overpass on the south side of town.

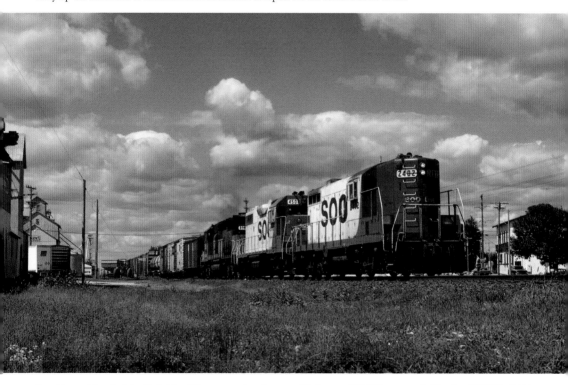

Southbound Soo freight 18 divides Allenton on the afternoon 23 August 1987. The train is led by Soo GP9 No. 2402, built by EMD in December 1954.

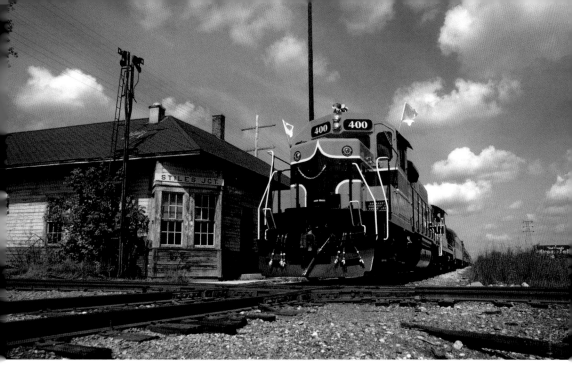

An Escanaba & Lake Superior passenger extra passes the depot at Stiles Junction on 29 August 1987. The train is operating from Crivitz to Green Bay on E&LS's former Milwaukee Road line from Milwaukee to the Upper Peninsula of Michigan.

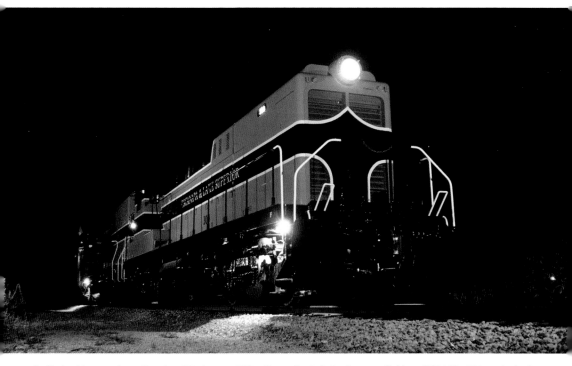

Softly burbling on the still night of 29 August 1987 is Escanaba & Lake Superior Baldwin RS12 No. 300 on the lead of a chartered passenger train at Howard, near Green Bay. Dressed in Great Northern-Inspired colors, the shiny Baldwin locomotive is far away from its former life as a Seaboard Air Line locomotive built in 1953.

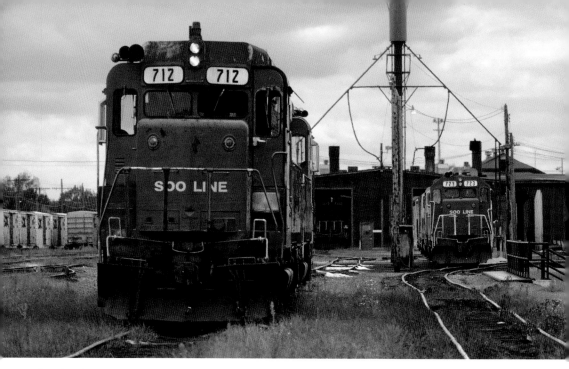

Soo Line locomotives gather on the east side of the railroad's roundhouse at the locomotive servicing facility at Stevens Point on 30 August 1987.

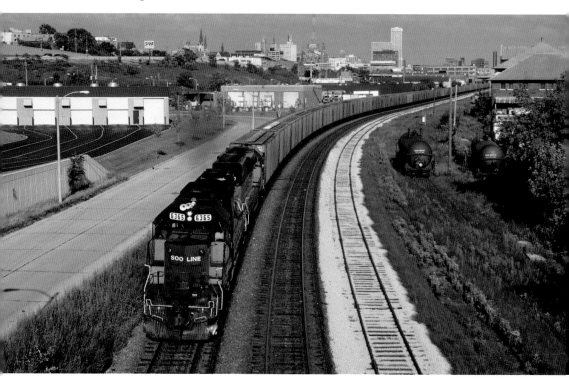

Beneath the Milwaukee skyline, Soo Line train 199 curves toward the North 25th Street overpass on the afternoon of 12 September 1987. The train is led by two former Milwaukee Road EMD SD40-2s, with lead Soo Line No. 6365 renumbered and relettered in a 'paint scheme' that became known as a 'bandit' because of its black patches.

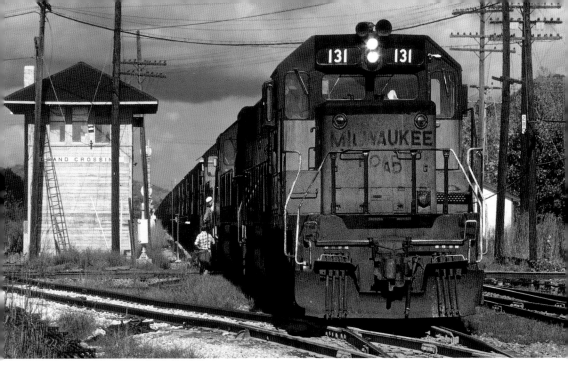

A westbound Soo Line coal train passes Grand Crossing tower at La Crosse on the afternoon of 20 September 1987. Powering the empties is Milwaukee Road EMD SD40-2 No. 131 along with two Burlington Northern locomotives.

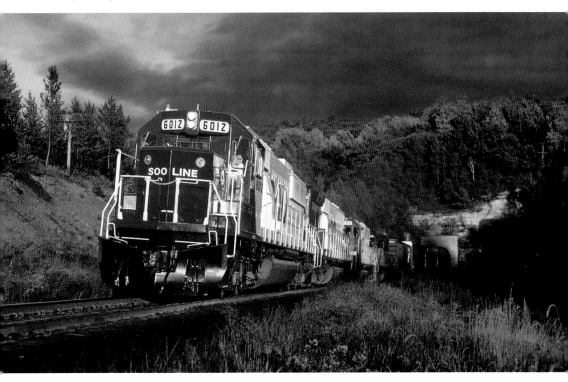

Brand-new Soo Line EMD SD60 No. 6012 leads the hot Ford auto parts train westbound out of Tunnel City in the very last light of 20 September 1987. Trailing is recently acquired and repainted former Burlington Northern EMD SD40B No. 6450 (formerly BN No. 7600), along with Soo SD40 No. 755 and Milwaukee Road SD40-2 No. 134.

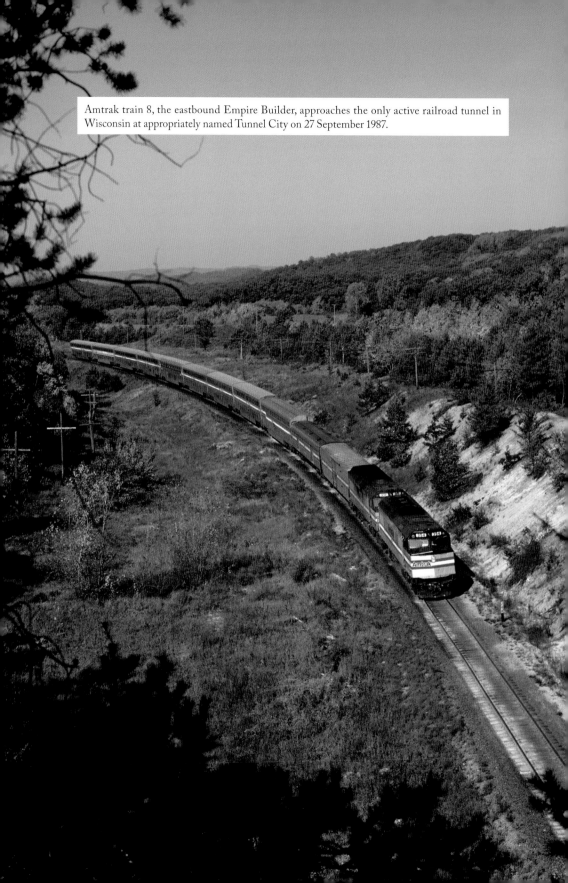

Amtrak train 8, the eastbound Empire Builder, approaches the only active railroad tunnel in Wisconsin at appropriately named Tunnel City on 27 September 1987.

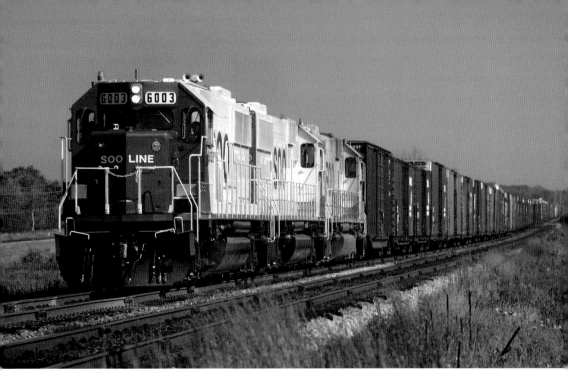

A trio of new Soo Line EMD SD60 locomotives quickly roll west with train 203 at Lewiston, between Portage and Wisconsin Dells, on the afternoon of 27 September 1987.

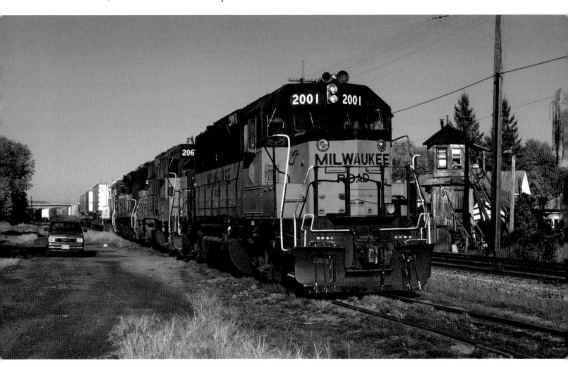

Milwaukee Road EMD GP40 No. 2001 leads Soo Line train 249 westbound out of the yard at La Crosse on 3 October 1987. A man in the elevated signal tower on the right still manually controls the nearby road grade crossings signals and gates at this late date.

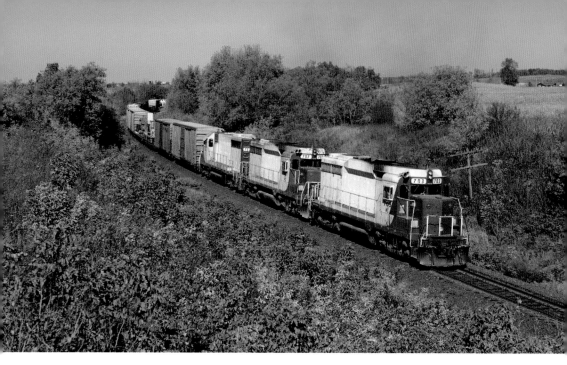

On 11 October 1987, the first Wisconsin Central freight train to climb Byron Hill out of Shops Yard at North Fond du Lac approaches the top of the grade at Byron. Crews at the locomotive shop in town spent the morning removing Soo Line lettering from the locomotives and applying WC initials to the cabs of these three units to symbolically show the flag of the new railroad as soon as possible.

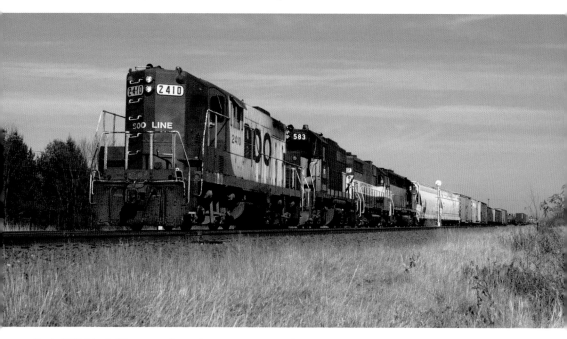

Early WC (that's Wisconsin Central, not water closet…) locomotive consists were kaleidoscopic, as seen on train 42 switching cars at Vernon, south of Waukesha, on 31 October 1987. Soo Line GP9 No. 2410 leads former Milwaukee Road 'bandit' SDL39 No. 583, WC GP38 No. 4007 and former Burlington Northern SD45 No. 6539 in the all-EMD lash up.

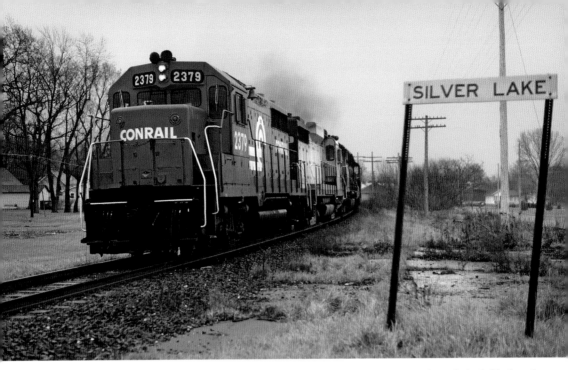

On a rainy and damp 7 November 1987, Wisconsin Central train 41 rolls smartly through Silver Lake, led by leased Conrail EMD GP35 No. 2379.

Officially beginning operations the previous day as a short line spin-off of Chicago & North Western, a Fox River Valley Railroad (FRVR) freight heads north out of Eden on the afternoon of 10 December 1988. It still looks like a C&NW train as it passes Abel's Dairy Farm, in business milking cows since 1857.

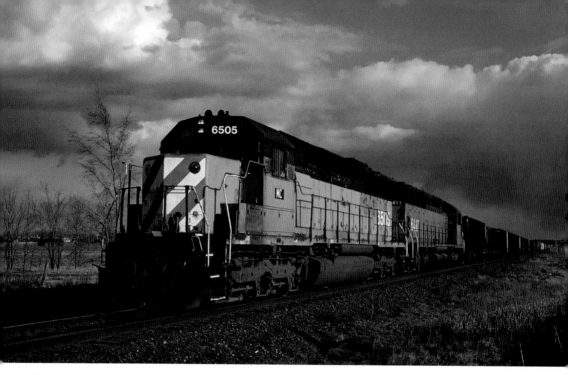

Wisconsin Central train 47 lets 'er rip departing Duplainville late on the afternoon of 6 April 1989. For what seemed like years (it was a few), WC power was dominated by the green machines acquired from Burlington Northern. I actually did get kind of tired photographing these big 20-cylinder locomotives in various shades of Cascade green, and welcomed the chosen ones that emerged in company colors. Looking back though, I'm glad I did photograph them, just like most everything else.

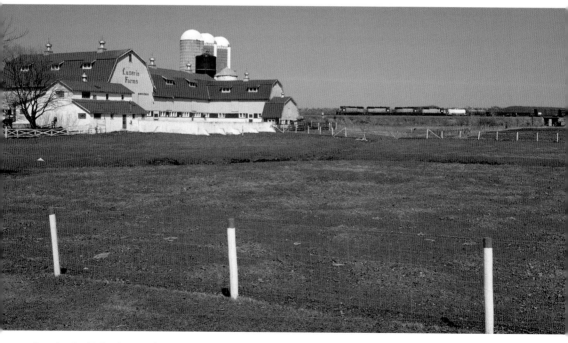

On a bright 23 April 1989 afternoon, northbound Fox River Valley Railroad PRGBA (Proviso Yard in Chicago to Green Bay) freight rolls past the stately barn of Luxerin Farms at Marblehead, just south of Fond du Lac.

Fox River Valley Railroad's PRGBA freight train passes through Kewaskum on 24 September 1989. All three of FRVR's EMD GP30s and a GP35 lead the train past some autumn pumpkins of substantial size.

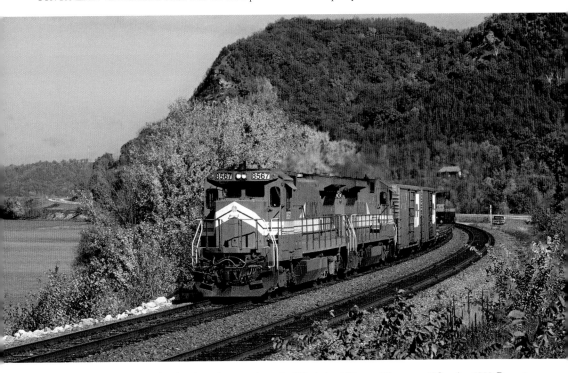

Burlington Northern manifest freight 144 curves along the Mississippi River at Victory on 7 October 1989. Powering the short freight is LMX B39-8 No. 8567 and GECX B39-8 No. 8000. BN leased 100 B39-8s from LMX built by GE and delivered to the railroad in October and November of 1987. Originally painted in the all-gray scheme as seen on No. 8567, they soon received red noses and numberboard areas to increase the visibility of the locomotives.

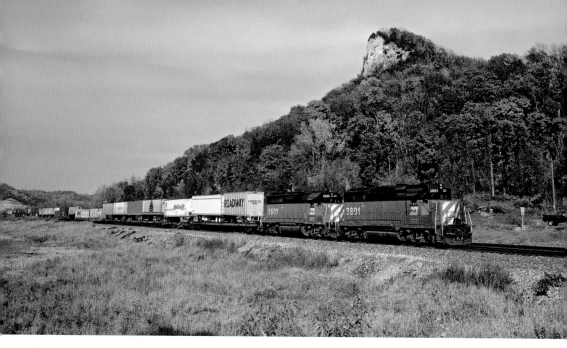

Burlington Northern second train 2 proceeds past some colorful autumn colors on the bluffs lining the tracks at La Crosse on 14 October 1989. Both locomotives are rebuilt, with GP39M No. 2801 being the former Union Pacific EMD GP30 No. 827, and GP40M No. 3501 being the former Chicago, Burlington & Quincy EMD GP40 No. 177.

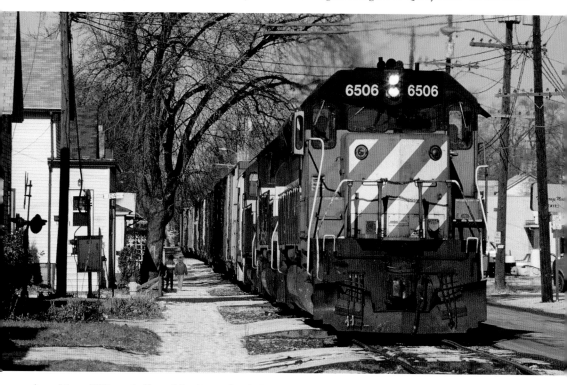

A southbound Wisconsin Central freight treads as lightly as it can through the front yards of homes lining Division Street in Oshkosh. Two children head down the sidewalk as the tonnage passes by, apparently used to the frequent distraction on this former Soo, now WC main line.

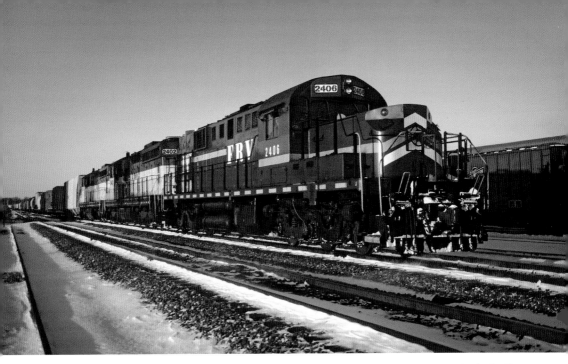

One of the few (maybe the only) times a former Lake Superior & Ishpeming Alco RSD15 'Alligator' led a Fox River Valley train, entering Butler Yard on the Chicago & North Western on a cold 24 February 1990. Trailing the former Santa Fe/LS&I/GB&W Alco are two former Chicago, Burlington & Quincy/Burlington Northern EMD SD24s, Nos 2401 and 2402.

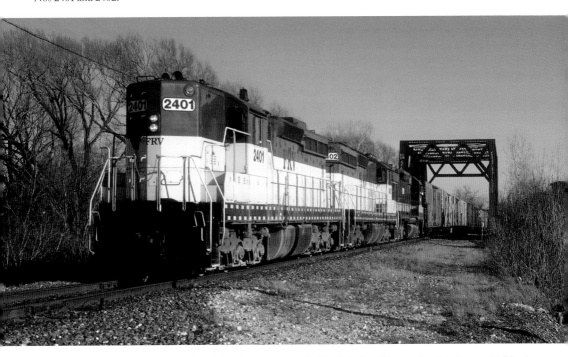

A northbound Fox River Valley Railroad freight passes over the Fond du Lac River at Fond du Lac on 25 March 1990. The train has FRVR's two former CB&Q/BN EMD SD24s and the lone former Southern Railway EMD SD35 No. 2500 for power.

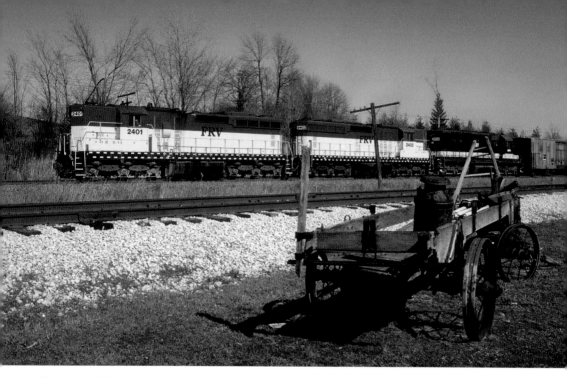

On a sunny 25 March 1990, a northbound Fox River Valley Railroad train is between Granville and Germantown, powered by a trio of FRVR six-axle locomotives. In the foreground is the Wisconsin & Southern's main line.

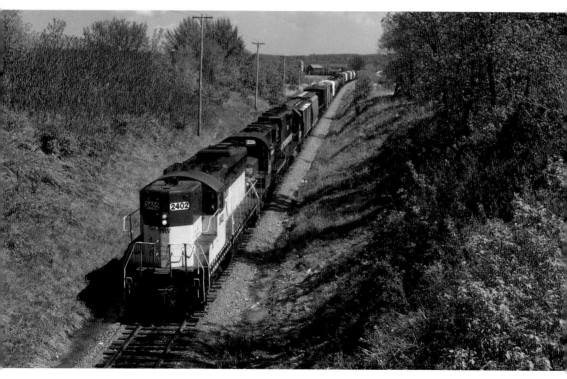

Approaching Fond du Lac is a northbound Fox River Valley freight on 13 May 1990. Expanding urbanisation from an sprawling city of Fond du Lac has changed this scene considerably.

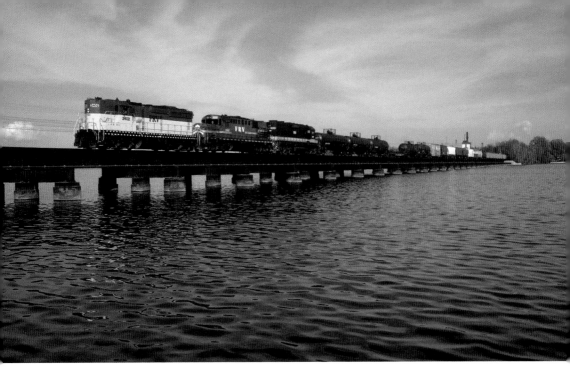

A Fox River Valley Railroad freight crosses the long bridge over Little Lake Butte Des Morts at Menasha on 13 May 1990. A colorful locomotive set from the Chicago & North Western spin-off line provides the motive power – former CB&Q/Burlington Northern EMD SD24 No. 2402, former LS&I Alco RSD15 No. 2407 and former Southern Railway EMD SD35 No. 2500. Unfortunately, unless you want to walk or cycle across this bridge, this part of the former C&NW line to Green Bay is abandoned onto the bridge and north, now called the 'Friendship Trail'.

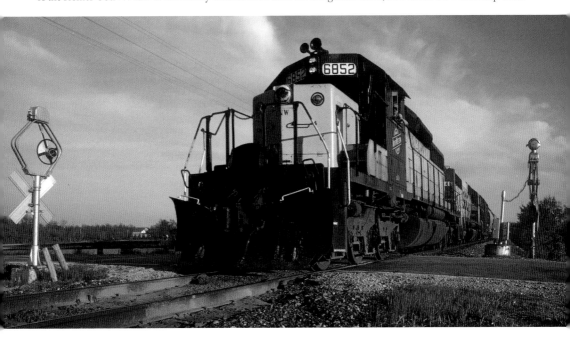

Chicago & North Western EMD SD40-2 No. 6852 and Soo Line EMD SD40 No. 741 power a Fox River Valley Railroad freight northbound, passing the wig wag crossing signals guarding the County Highway NN grade crossing north of Jackson, late in the afternoon of 28 May 1990.

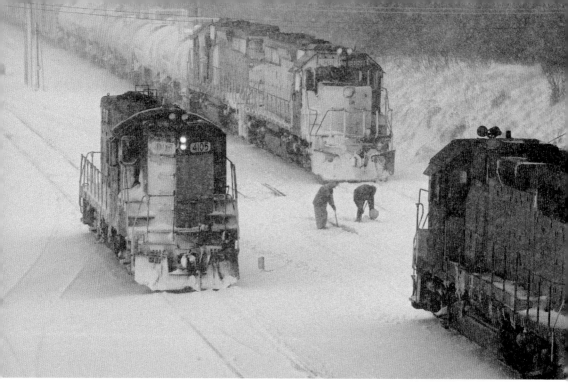

On 3 December 1990, Chicago & North Western's PRGBA (Proviso Yard to Green Bay) freight has finished making a set out at Butler Yard. Snow is coming down hard, and is starting to cover the rails. A southbound train has come to a stop at the reversed switch on the crossover. The crew of a yard engine, GP7 No. 4105, has also come over to help the crew of PRGBA clean out the switch. Soon, both trains will be on there way, and the switcher will go back to work shuffling cars in the yard. In the middle of a Wisconsin blizzard, railroading doesn't stop for the weather.

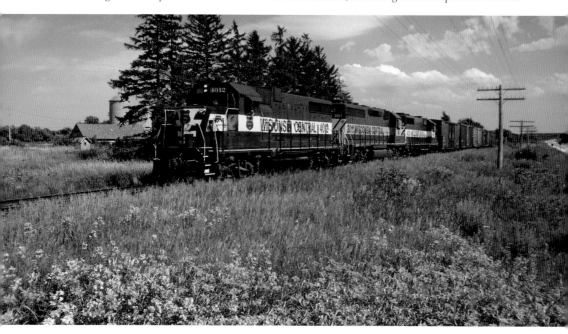

Wisconsin Central train 47 approaches Sussex as it passes a field of tiger lilies growing along the tracks near milepost 105 on 6 July 1991.

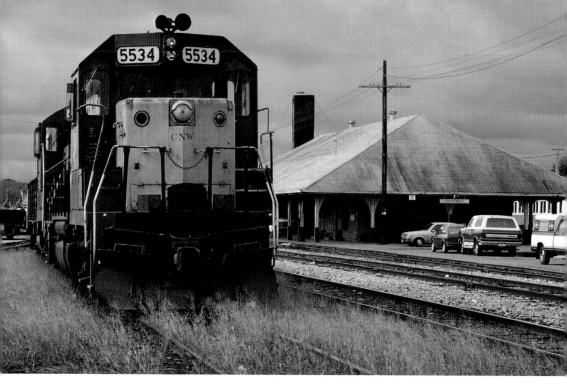

Chicago & North Western EMD GP40 No. 5534 and an older EMD GP7 sit in front of the depot at Spooner on the railroad's Eau Claire to Superior main line on 19 September 1991.

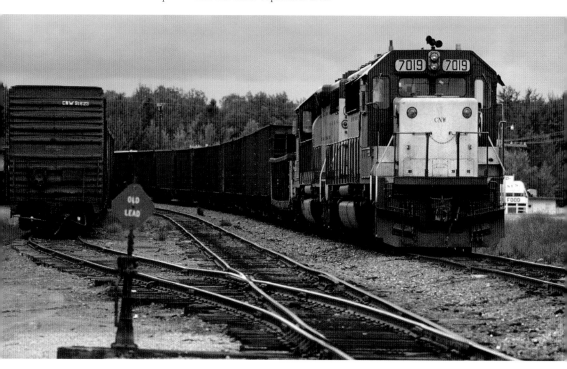

Chicago & North Western's PRITA (Proviso Yard in Chicago to Itasca Yard in Superior) freight waits for a new crew at Spooner on a cloudy 19 September 1991. The train is led by C&NW SD50 No. 7019, built by EMD in December 1985.

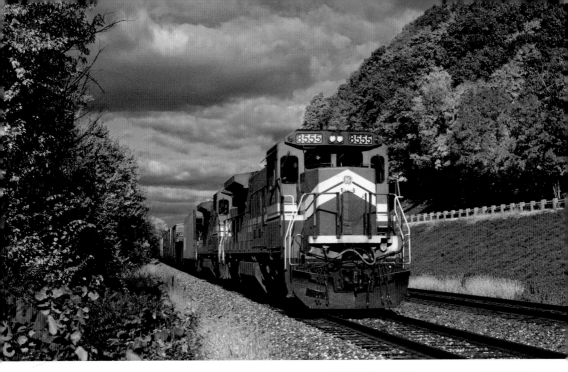

An eastbound Burlington Northern freight, powered by a pair of LMX (General Electric Leasing) GE B39-8 locomotives, passes through Lynxville on the perfect autumn day of 12 October 1991. LMXs were never a favorite to photograph, but they don't look too bad with some nice fall color.

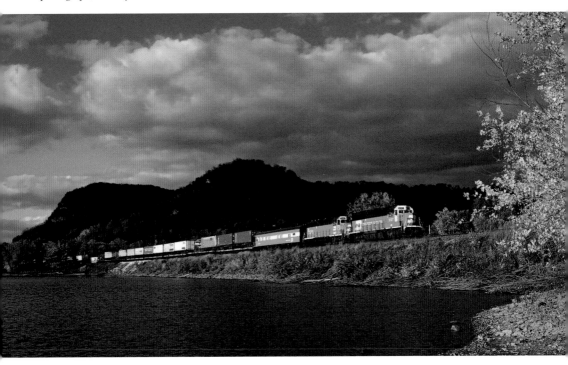

An eastbound Burlington Northern intermodal train speeds through Victory along the Mississippi River late in the afternoon of 12 October 1991. Behind EMD GP50 No. 3127 and EMD GP40M No. 3511 is BN business car 'Columbia River'.

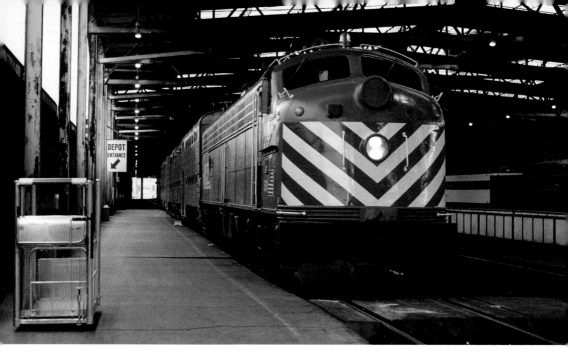

For several years in the early 1990s, Amtrak would borrow some equipment from Chicago's Metra to sub for Amtrak trains on the Chicago to Milwaukee 'Hiawatha' corridor on Thanksgiving holiday weekend. This would allow Amtrak to utilise the passenger cars and locomotives normally used on the run to handle increased holiday ridership by expanding capacity on other trains. On 30 November 1991, Metra EMD E8 No. 518 and three bi-level commuter coaches sits inside the trainshed at the Milwaukee's Amtrak station waiting for departure back to Chicago.

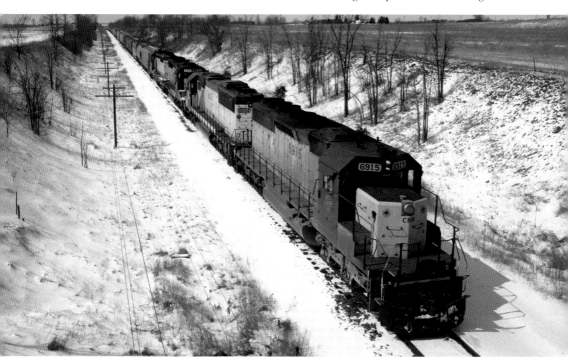

On Chicago & North Western's Adams Line, a C&NW potash extra heads eastbound through North Lake on a wintery 22 March 1992.

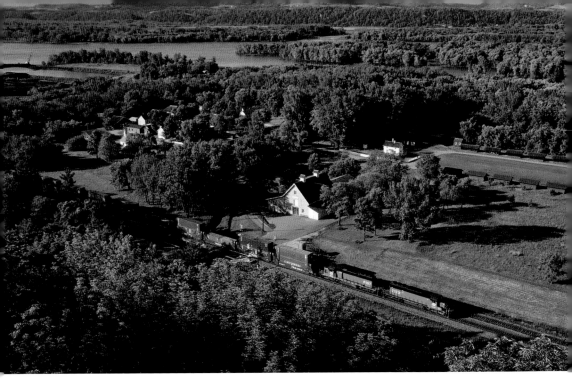

A westbound Burlington Northern stack train passes the entrance to the Stonefield Historic Site at Cassville on 24 May 1992. In an idyllic setting along the Mississippi River, Stonefield is the 2,000-acre estate of Wisconsin's first governor, Nelson Dewey, and features over thirty buildings that celebrates Wisconsin's rich agricultural heritage in a beautiful setting for everyone to enjoy.

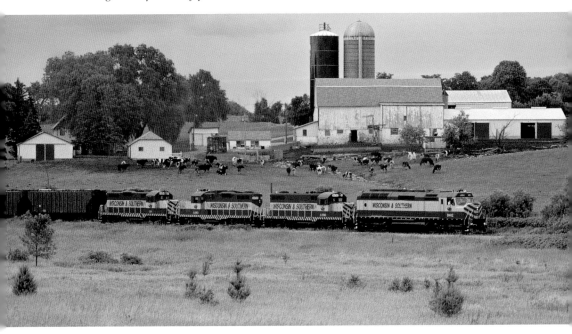

Wisconsin & Southern EMD F45 No. 1002 leads three EMD GP9s on an eastbound train at Woodland, east of Horicon, and has just crossed Lilac Road on 6 July 1992. WSOR didn't use the big F45 cowl locomotives for very long since their greater weight was hard on the track structure.

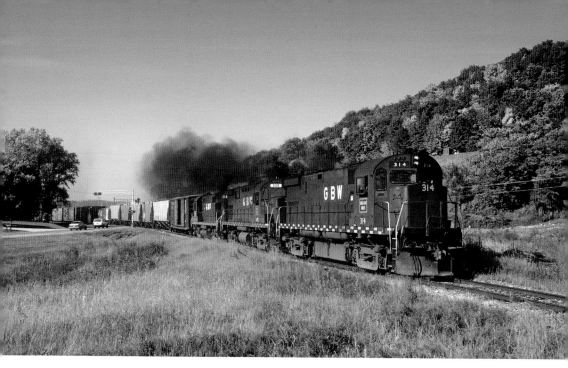

Green Bay & Western train 2 lays down a good smoke screen, common to accelerating Alco locomotives, as it notches it up through Marshland on 3 October 1992. Alco C424 Nos 314 and 320, along with Alco RS27 No. 316, power the eastbound train.

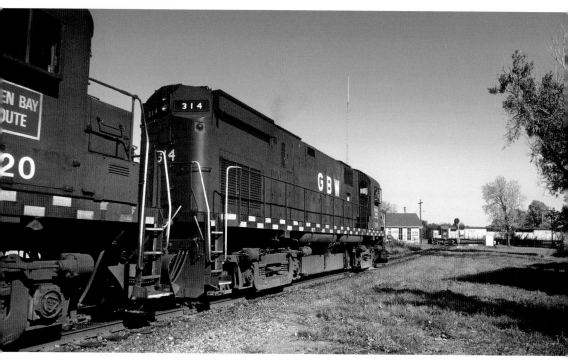

Cooling its heels at Merrillan for a crew change and some switching is Green Bay & Western train 2. Over at the Chicago & North Western crossing by the Merrillan depot, a C&NW empty ore train heads north (west) over the diamond with EMD SD50s Nos 7007 and 7001, on a brilliant 3 October 1992.

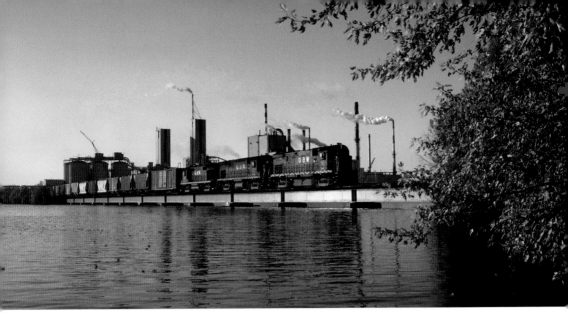

Green Bay & Western train 2 crosses the Wisconsin River at Wisconsin Rapids on the afternoon of 3 October 1992. The state is known for its paper production, and a large paper plant looms behind the eastbound train.

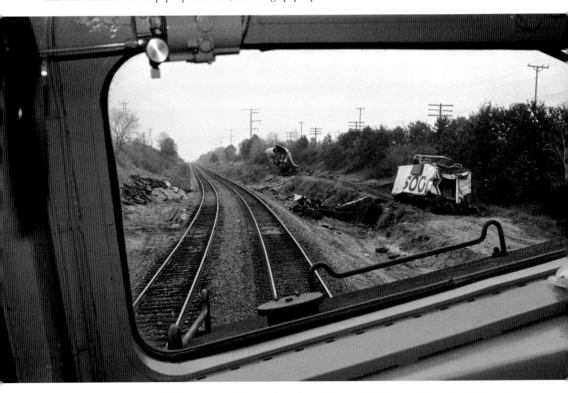

Aboard the lead EMD F40PH locomotive of Amtrak's eastbound Empire Builder on 9 November 1992 and just east end of Rio, about 14.5 miles from Portage, we pass the scene of a derailment. The cause was that an eastbound train was stationary, waiting for permission through work limits, when another train came up from behind with the radio turned down and rear-ended the stopped eastbound running against the current of traffic on the westbound main. The scattered freight car parts and crushed autorack and caboose illustrate the dangers of railroading. Obviously, Soo Line caboose No. 121 met its demise here.

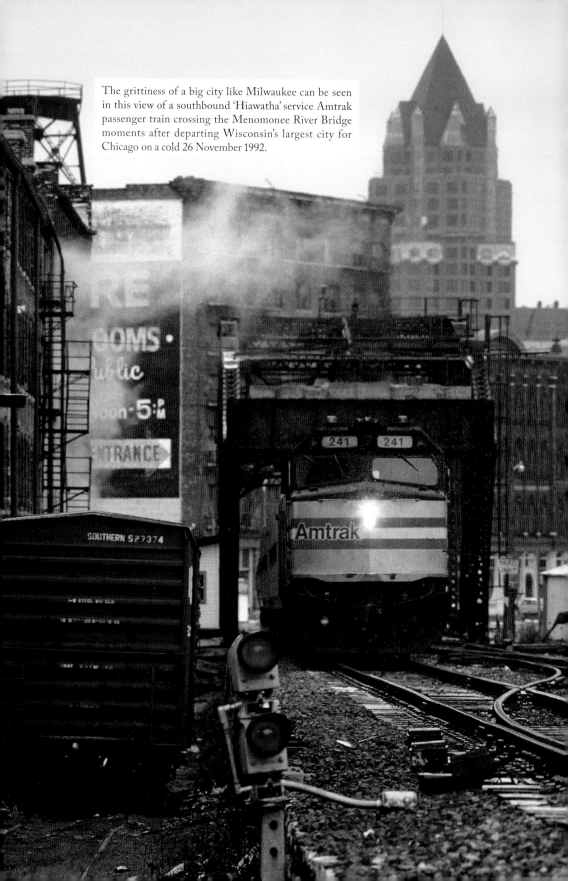

The grittiness of a big city like Milwaukee can be seen in this view of a southbound 'Hiawatha' service Amtrak passenger train crossing the Menomonee River Bridge moments after departing Wisconsin's largest city for Chicago on a cold 26 November 1992.

Soo Line train 214, powered by lone EMD SD60M No. 6061, waits for a signal at Milwaukee on 27 November 1992. Passing by on the main line is Amtrak train 338 to Chicago, substituted with Chicago Metra commuter equipment for the Thanksgiving holiday weekend. The engineer of the passenger train is in the bi-level cab car, with the locomotive (out of sight behind train 218) three cars back, pushing the train southbound.

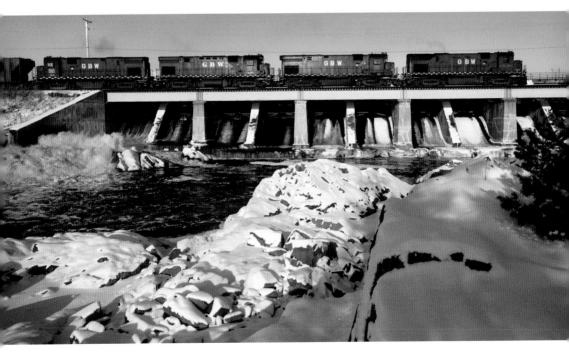

Green Bay & Western train 2 crosses a bridge parallel to a dam on the Black River that forms Lake Arbutus at Hatfield on 5 December 1992. The train is pulled by a quartet of GB&W Alco C424 locomotives: Nos 312, 311, 320 and 314.

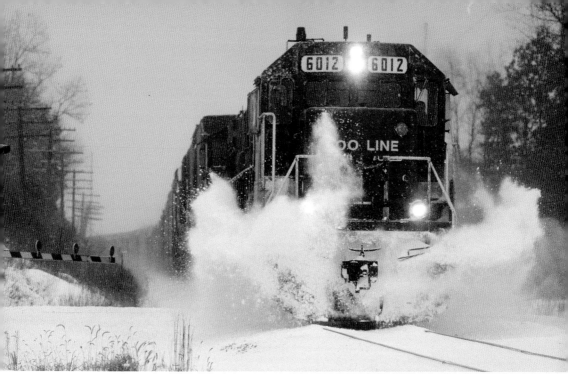

A Soo Line freight bursts through some snow at a highway grade crossing at Hartland on its journey west on the former Milwaukee Road main line on a snowy 21 January 1993.

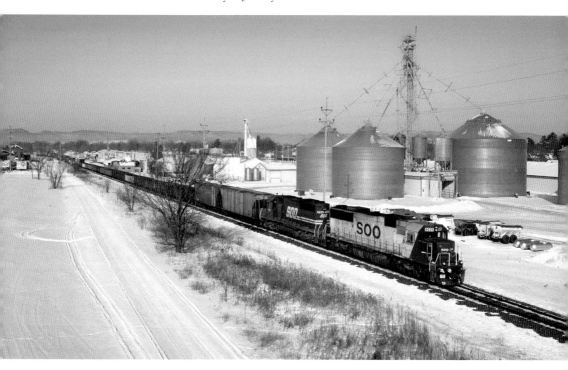

Side by side with a well-used snowmobile trail at West Salem is an eastbound Soo Line train on 27 January 1993. The trail is actually the old abandoned Chicago & North Western line that ran from Tunnel City to La Crosse, roughly parallel to the Soo Line's former Milwaukee Road main line, and is now called the La Crosse River Trail.

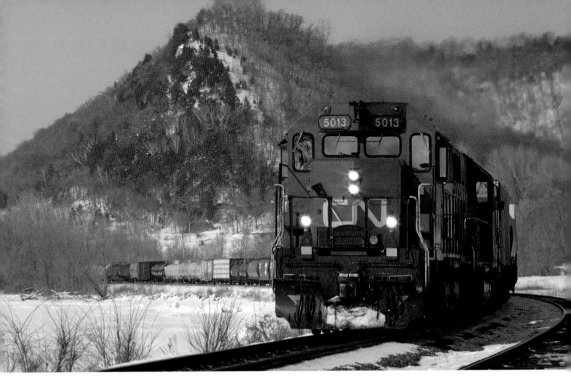

Canadian National EMD SD40 No. 5013 leads eastbound CN train 340 through Genoa on Burlington Northern's main line along a frozen Mississippi River on 27 February 1993.

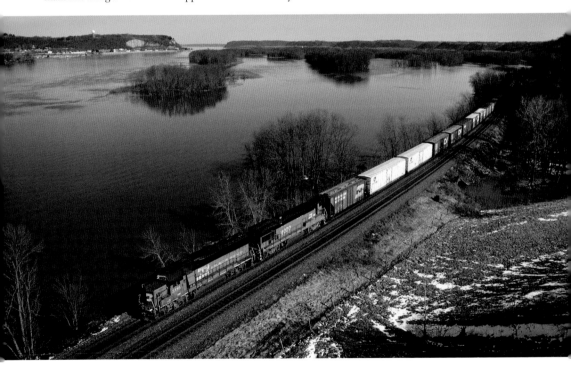

Burlington Northern freight train 104 is still in Wisconsin as it approaches the state line at East Dubuque, Illinois, while tracing the banks of the Mississippi River on 3 April 1993. The eastbound train is powered by EMD GP50 No. 3118 and cabless GE B30-7A No. 4020.

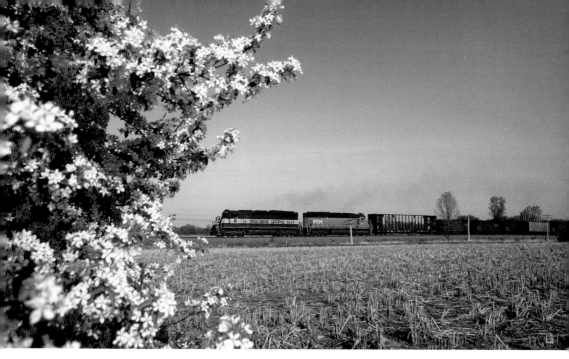

Two big EMD SD45 locomotives haul Wisconsin Central train 49 out of Duplainville, passing a blooming apple tree on 13 May 1993.

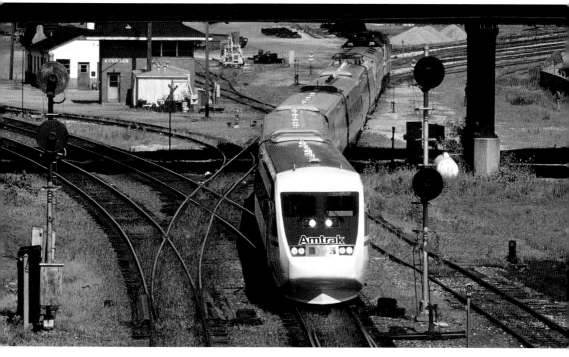

In 1992/3, Amtrak tested the Swedish-built X2000. From May to July 1993, the train was taken on a national tour and displayed around the Amtrak system. Here, the high-speed train negotiates Soo Line (former Milwaukee Road) trackage past Cut Off Tower in Milwaukee on 28 June 1993. The train will clear the interlocking and then back to Milwaukee's downtown Amtrak station. It was a very rainy year and this, combined with leaking grain cars, makes Cut Off look a bit more green than usual!

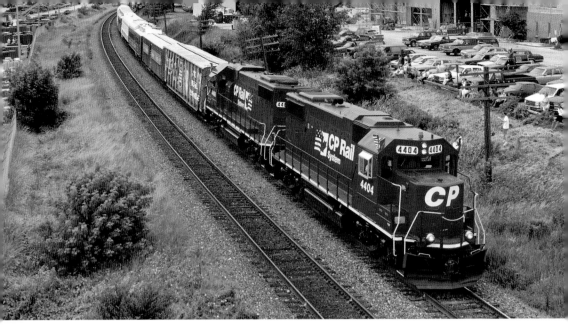

Two freshly painted former Soo Line GP38-2s pull the Great Circus train through Pewaukee (just west of Duplainville) on 6 July 1993. The twenty-seven-car train is loaded with animals in stock cars, dignitaries in heavyweight passenger cars, and plenty of flats loaded with historic wooden circus wagons from Circus World Museum in Baraboo. The colorful wagons, performers, animals and bands will traverse the streets of Milwaukee during the annual Great Circus Parade.

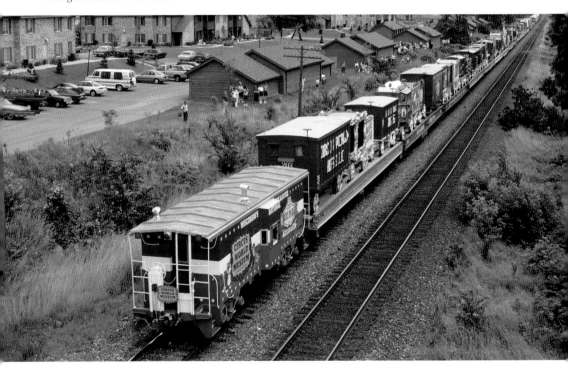

Hundreds of spectators line the tracks to see the Great Circus train slowly make its way east over the former Milwaukee Road main line at Pewaukee on 6 July 1993. Carrying the markers of the colorful train is former Chicago & North Western caboose, CWMX No. 21. Circus World Museum at Baraboo is home to the world's largest collection of intricately carved and beautifully restored circus wagons.

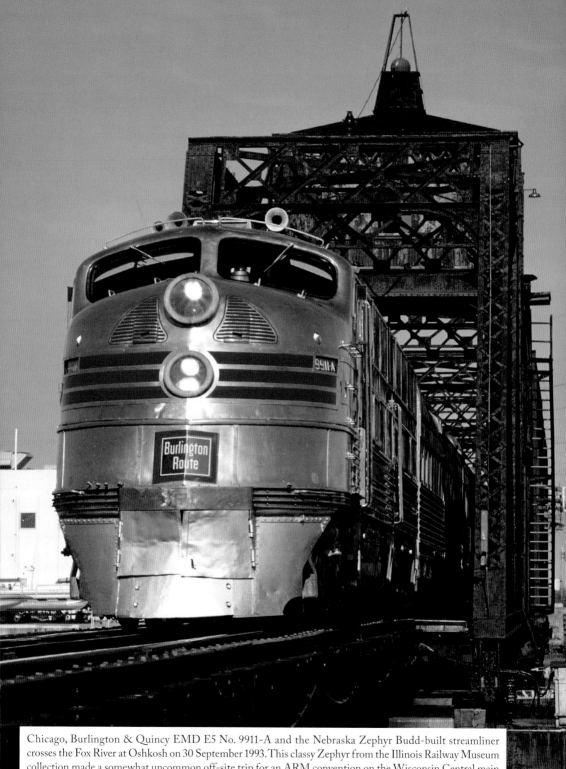

Chicago, Burlington & Quincy EMD E5 No. 9911-A and the Nebraska Zephyr Budd-built streamliner crosses the Fox River at Oshkosh on 30 September 1993. This classy Zephyr from the Illinois Railway Museum collection made a somewhat uncommon off-site trip for an ARM convention on the Wisconsin Central main line from Burlington (Wisconsin) to Neenah and return. This bridge and route through Oshkosh is now abandoned, replaced with the nearby parallel Fox River Valley Railroad route that WC acquired in the FRVR/ Green Bay & Western merger.

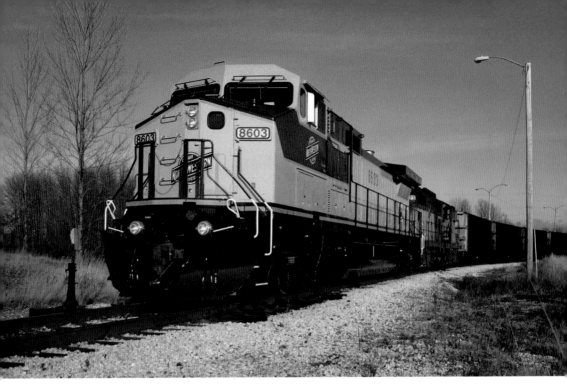

On its very first run, brand new Chicago & North Western GE C44-9W No. 8603 is paired up with vintage C&NW GP7 No. 4323 switching a train of coal empties on the spur into Sheboygan Power Plant at Sheboygan on the afternoon of 11 December 1993.

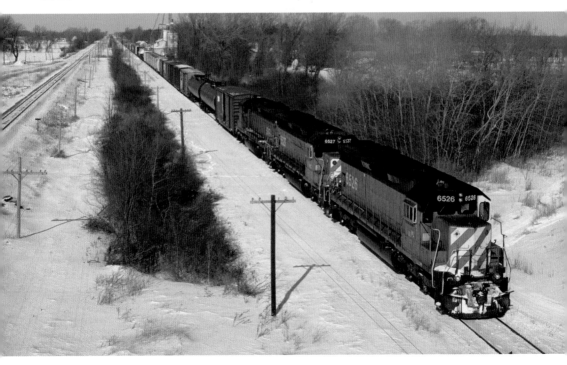

Wisconsin Central train 12, powered by a trio of former Burlington Northern EMD SD45s still painted Cascade green, cruises through Van Dyne, approaching North Fond du Lac on a snowy 6 February 1994.

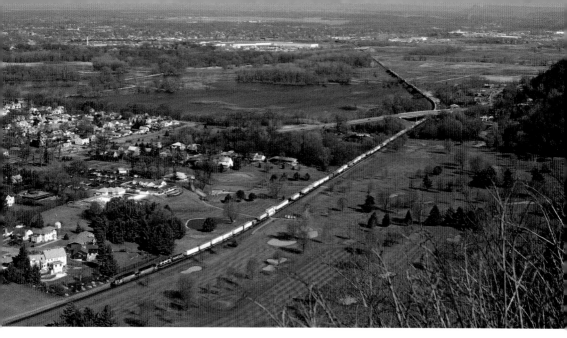

In a view that is from an impressive overlook in Grandad Bluff Park, Burlington Northern 'Expediter' intermodal train 42 rolls past – actually through – part of Forest Hills Public Golf Course at La Crosse on the morning of 23 April 1994. It actually has a golf cart grade crossing to access the entire course from the clubhouse. This close to the tracks, surely 'fore' has been yelled as a ball went awry toward a train. Surely, a nicely timed blow of an airhorn from an engineer on a passing train messed up a shot or swing. It's a great place to mix in a little train watching while chasing around a little white ball.

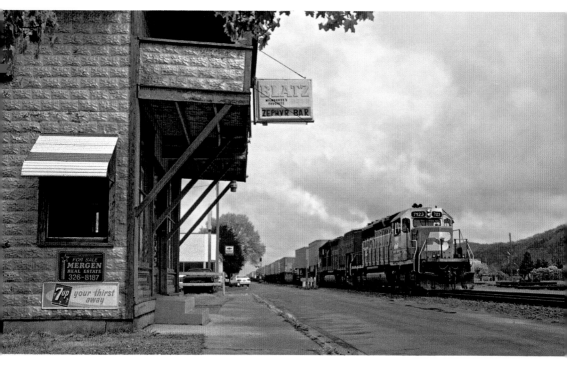

Where shiny stainless steel Zephyrs once barreled through on the busy route between Chicago and the Twin Cities, Burlington Northern 'Expediter' intermodal train 42 cruises by the now empty Zephyr Bar across the street from the depot at Prairie du Chien on a rainy 7 May 1994.

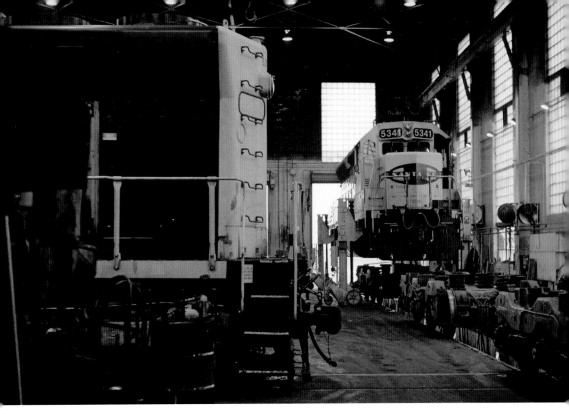

Wisconsin Central prepares its newly purchased Santa Fe EMD SD45s with some truck work, among other things, in the shop at North Fond du Lac on 8 October 1994. The former Soo Line facility, a locomotive shop, car shop and extensive yard there, was simply known as 'Shops'.

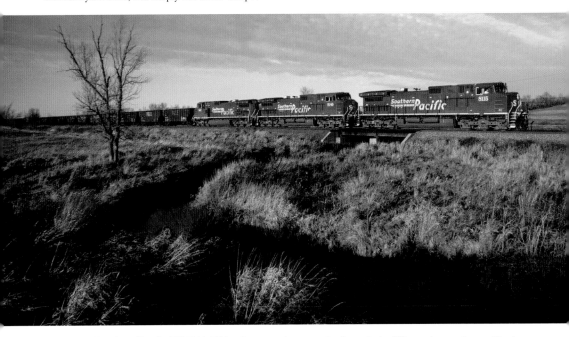

Three new Southern Pacific GE C44-9Ws take a taconite ore train through the Wisconsin marshes and is about to cross Highway 28 at Theresa on 29 October 1994.

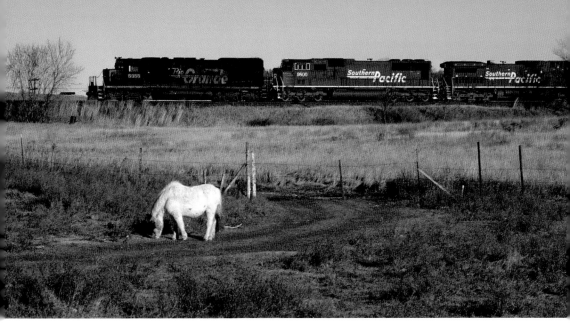

In February 1994, Southern Pacific and Wisconsin Central scored a major coup when they received the ore contract from Utah's Geneva Steel. The railroads began operating taconite ore trains from Minntac to Utah, and instead of sending the empty cars back to Minnesota for reloading, they back-hauled Utah and Colorado coal eastward to midwest U.S. customers, making both moves much more cost-effective. On the afternoon of 25 November 1994, an empty is heading back to Minntac for loading, after bringing coal east. The train is led by Rio Grande EMD SD40T-2 'Tunnel Motor' No. 5355, complete with tunnel soot and filth, and passes a pony at Nelsons near Amherst Junction.

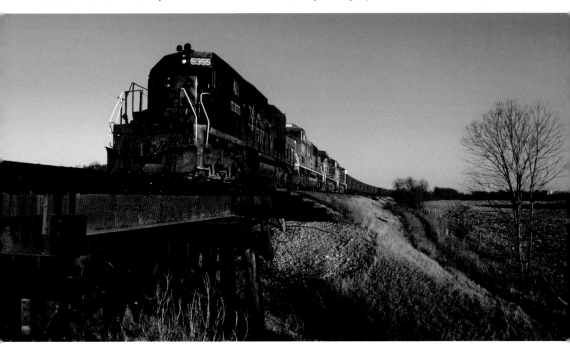

An empty Wisconsin Central unit coal/taconite ore train, operated in conjunction with Southern Pacific, curves over a trestle between Amherst Junction and Custer, and will soon be arriving at the crew change of Stevens Point. These trains frequently utilised SP (Rio Grande was part of SP since 1988) locomotives on the WC.

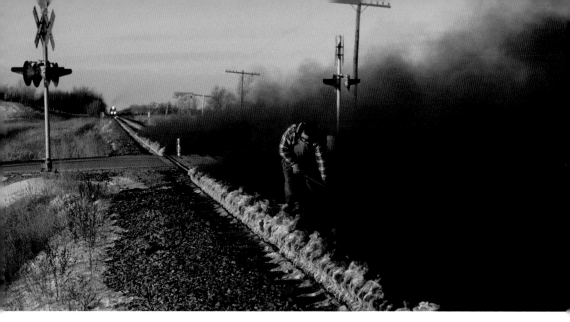

A bitter cold winter day has caused a rail break on the Wisconsin Central main line entering Shops Yard near the Subway Road grade crossing at North Fond du Lac on 11 December 1994. This particular break is called a 'pull apart', where the rail contracted enough to shear off the track bolts at a rail joint. A kerosene-soaked rope is placed alongside the offending rail and lit, creating enough heat for the rail to expand closing up the joint, and allowing the holes to once again line up and new bolts installed. A WC trackman uses a spike maul to help loosen the warming rail on the tie plates, allowing it to slide more freely.

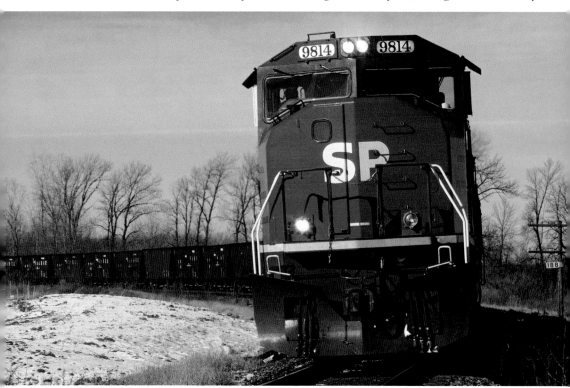

A Southern Pacific/Wisconsin Central unit taconite ore train bound for Geneva Steel passes milepost 188 at Neenah on 11 December 1994.

RAIL CROSSING ROAD

3 TRACKS

Wisconsin Central train 8 approaches a grade crossing in Van Dyne that is still protected by a wig-wag crossing signal on 26 December 1994.

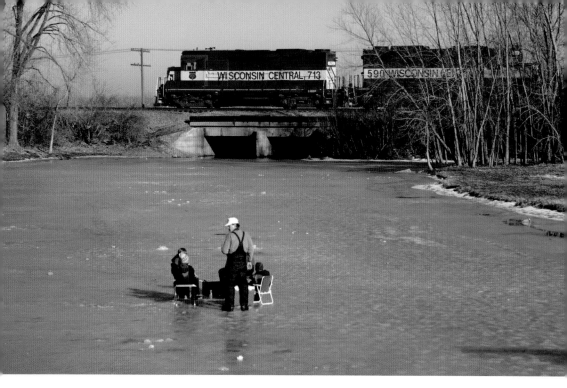

A family is out ice fishing on a frozen Neenah Slough, as Wisconsin Central train 65 passes by in the background on 26 December 1994. Train 65 is powered by EMD GP30 No. 713, a former Soo Line unit equipped with AAR type B trucks from an Alco trade-in, and former Milwaukee Road EMD SDL39 No. 590.

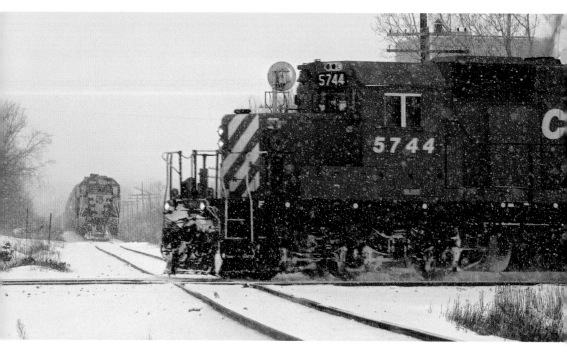

In a 22 January 1995 Wisconsin snowstorm, a Soo Line eastbound, with Canadian Pacific power, crosses the diamonds at Duplainville while Wisconsin Central train 243 waits for the plant. The WC train will have to wait for train 46 to head to Milwaukee too before it can head northbound.

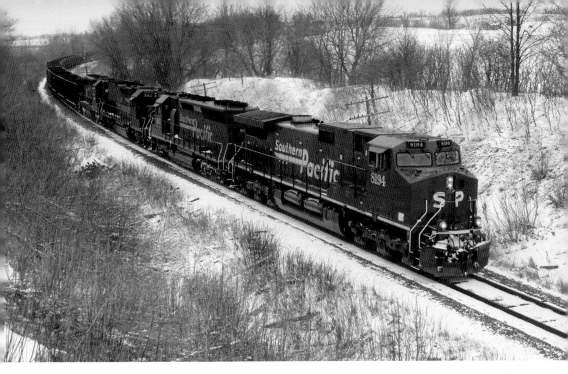

New Southern Pacific GE C44-9W No. 8194 leads a southbound Wisconsin Central taconite ore train up Byron Hill at Byron on 26 February 1995. Trailing No. 8194 is an eclectic trio of EMDs – SP No. 8607, a former PRR/PC/CR/C&NW/NRE SD45 rebuilt by MK into a SD40M-2; Rio Grande SD40T-2 No. 5411; and finally former N&W, now EMD Leasing, SD35 No. 1642.

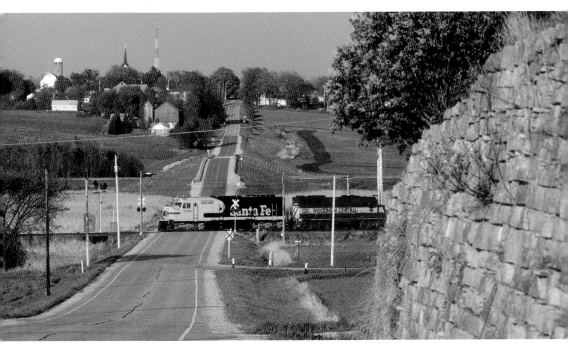

Rolling through a bucolic Wisconsin scene north of Allenton is northbound Wisconsin Central train 45, with bright Santa Fe EMD F45 'cowl' unit No. 5959 leading the way across an empty County DW on 19 May 1995. In the background is the farm community of St Anthony.

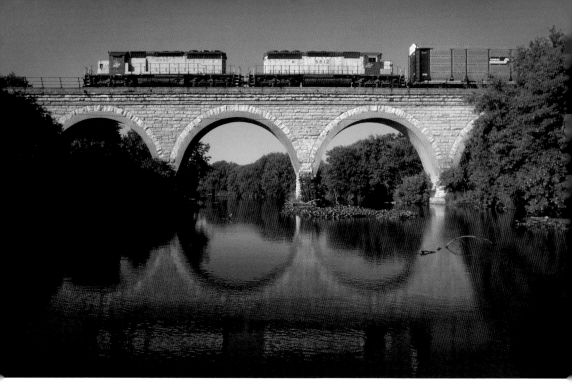

In a view from wading into the water, Chicago & North Western's Janesville to Chicago freight crosses the Tiffany Bridge over Turtle Creek at Tiffany on the morning of 29 July 1995. The eastbound train is led by a pair of C&NW EMD SD40-2 locomotives.

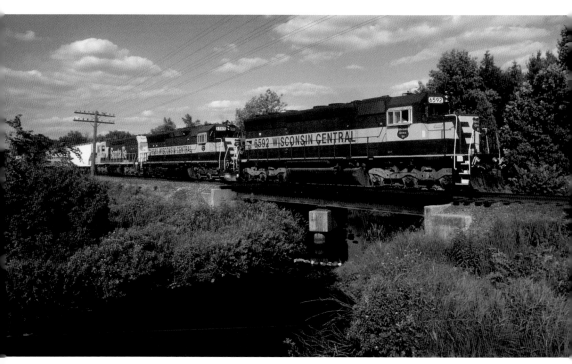

Three 3,600-hp EMD SD45s whisk Wisconsin Central train 44 southbound across Pebble Brook between Waukesha and Vernon on a sunny 1 July 1995.

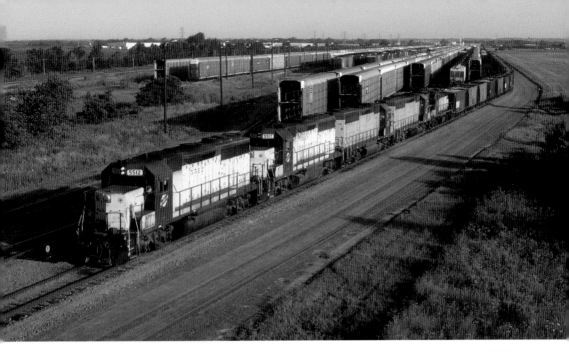

Loaded with 'Pink Lady' quartz ballast from the company-owned Rock Springs quarry, a Chicago & North Western ballast train departs Janesville on the morning of 8 July 1995. The large yard full of auto racks and auto parts boxcars is traffic for the extensive automobile factory, General Motors' Janesville Assembly Plant, on the south side of town. Opened in 1919, it was the oldest operating GM plant, until it was completely shut down in 2009.

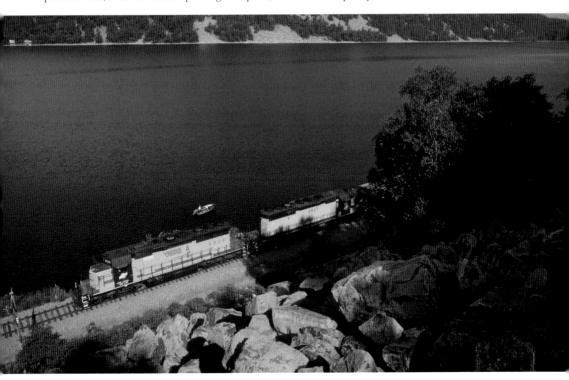

Chicago & North Western EMD SD40-2 Nos 6826 and 6827 trundle along the shore of scenic Devil's Lake, near Baraboo, en route to Milwaukee with the ever-popular circus train.

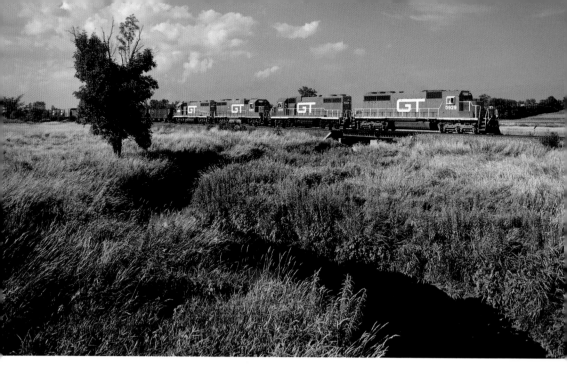

A Grand Trunk Western rock train travels south on the Wisconsin Central at Theresa on 23 July 1995. Powering the train is a colourful set of four GTW EMD locomotives: SD40 No. 5929, GP38-2 No. 5711, GP38AC No. 6207 and GP38-2 No. 5708.

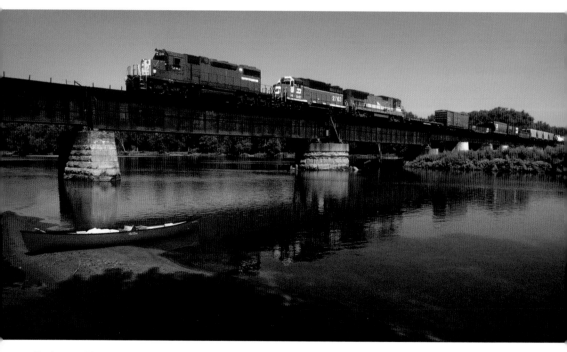

Burlington Northern train 144 crosses the Wisconsin River at Crawford east (compass south) of Prairie du Chien on the nice summer day of 30 July 1995. A former Reserve Mining EMD SD38-2, now GATX No. 1243, leads BN GP39E No. 2763 and GE LMX No. 8594 as power on the eastbound train. In the foreground is our transportation to the bridge.

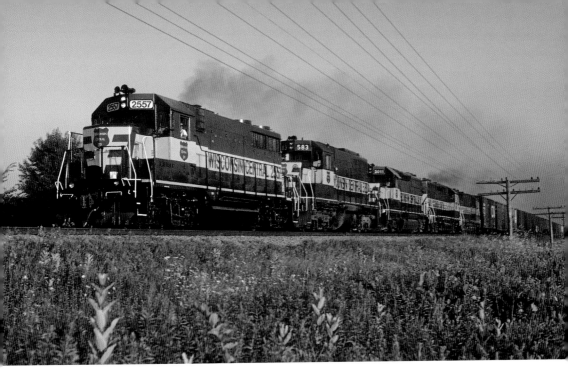

Storming out of Duplainville after making a pick up, Wisconsin Central train 47 hurries by near sunset on 5 August 1995. WC No. 2557 is a former Chicago & North Western locomotive, acquired through the WC's Fox River Valley Railroad merger in 1993. Trailing the freshly painted GP35 in the all-EMD consist is a SDL39, two GP40s and another GP35.

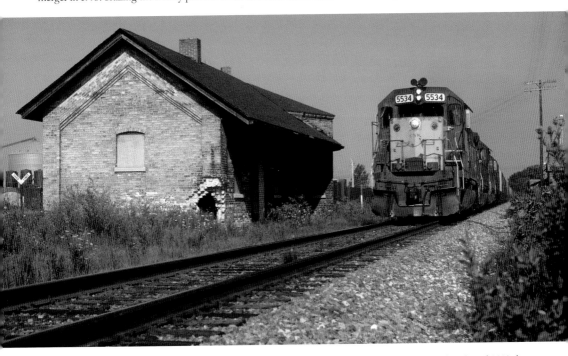

Chicago & Northern Western's freight from Janesville is eastbound at Clinton, passing the abandoned 1912 depot on the morning of 12 August 1995. This station at Clinton Junction stood at the crossing of C&NW's Chicago to Janesville route, and Milwaukee Road's 'Southwestern' line between Racine and Kittredge, Illinois. The Milwaukee line was abandoned by the time of this photo.

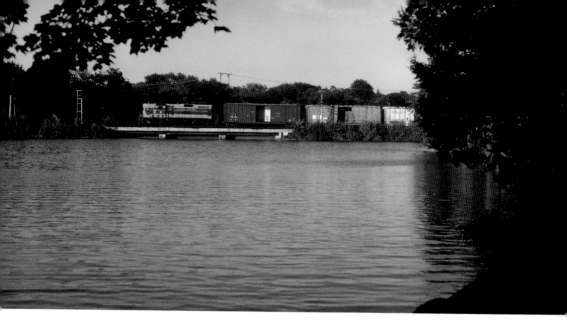

A Wisconsin Central local switches at Burlington along the shore of Echo Lake on 22 August 1995. WC bought Algoma Central Railway on 1 February 1995, and EMD GP9 No. 1501 still wears its classy AC paint scheme.

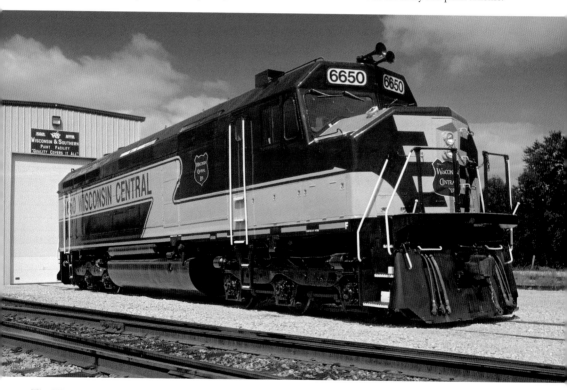

The Wisconsin & Southern's Paint Facility in Horicon has just finished painting Wisconsin Central EMD F45 No. 6650 on 17 September 1995. A contest was run internally on the railroad to come up with a 'special' image for these cowl locomotives that were recently acquired from Santa Fe, but a single contestant's idea wasn't chosen. Instead, design features from several winners was cherry-picked and a composite image was born, and this was the result. A perfect scheme? Perhaps not, but a F45 in fresh paint in the mid-'90s was still a good thing. WC bought six F45s and one FP45 from the Santa Fe in 1994-95; WC No. 6650 was formerly Santa Fe No. 5955.

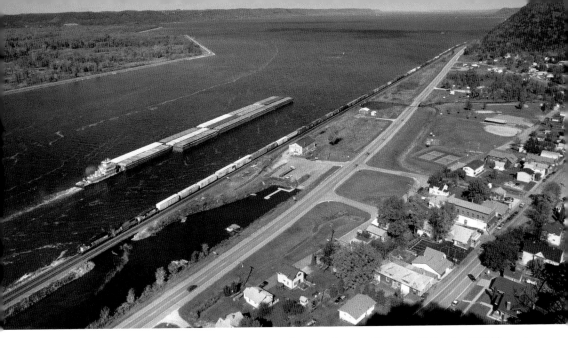

Burlington Northern train 110 cruises along the mighty Mississippi River at Genoa on 15 October 1995. The train is powered by EMD SD40-2 No. 7013, with a Santa Fe GP60B and BN GP10 (rebuilt GP7) trailing. It is heading downriver after changing crews at La Crosse, but a tug with barges that has just passed through U.S. Lock and Dam No. 8 churns its way upstream. Wisconsin Highway 35, the 'Great River Road', follows Old Man River through here, while the old highway through Genoa is now Main Street. There was no drone used here – good hiking boots and a nice climb up one of the Mississippi River valley's numerous bluffs provided the vista.

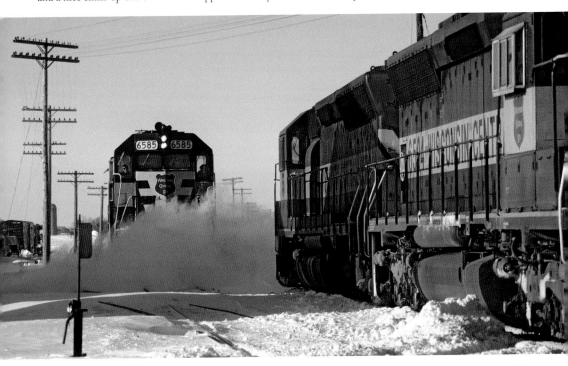

Kicking up some fresh snow, Wisconsin Central train 46, with WC EMD SD45 6585 leading, is meeting train 49 at Bryon on a clear and snowy 27 January 1996.

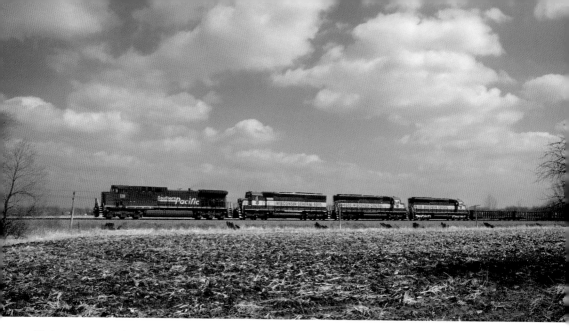

Under a picture-perfect sky, a Wisconsin Central freight heads northbound out of Duplainville on 15 March 1996. The train is powered by Southern Pacific GE AC4400CW No. 119, and a trio of WC EMD SD45s: Nos 6510, 6502 and 6517.

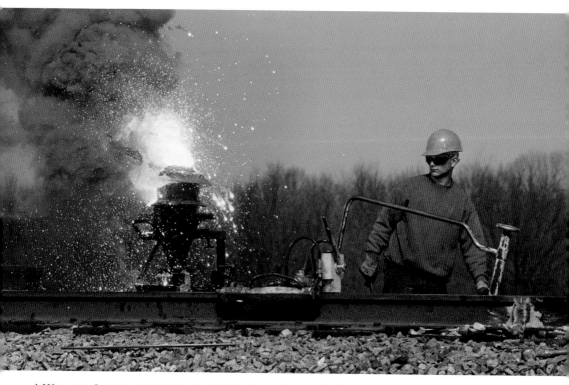

A Wisconsin Central welder has just lit off a thermite weld pot on the WC main line at Duplainville on 23 March 1996. To permanently join two rails together, a one-time-use form is attached to the rails surrounding the joint, and molten iron heated to an incredibly hot temperature in a reaction crucible located directly above is poured into the form, creating the weld.

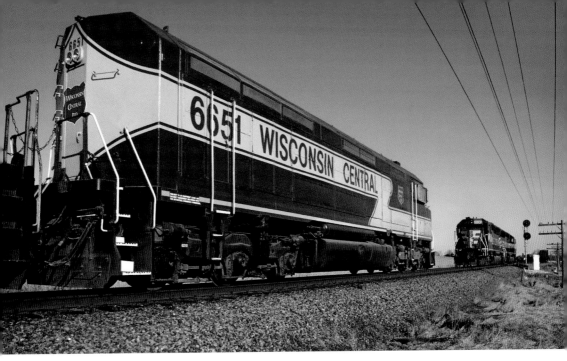

Two Wisconsin Central trains do a power swap at the south end of Byron siding on the morning of 23 March 1996. WC No. 6651 is a former Santa Fe EMD F45 locomotive and features a paint scheme unique to WC's cowl units.

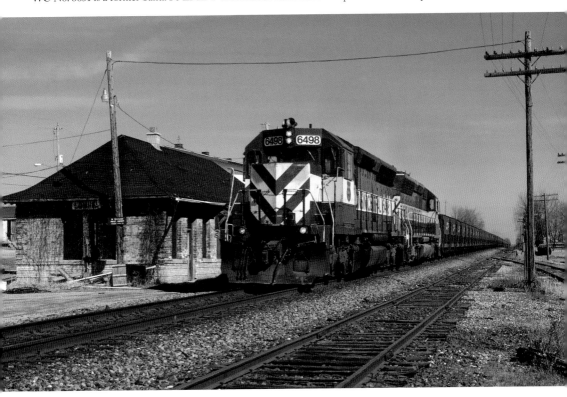

Bound for interchange to the Elgin, Joliet & Eastern Railway in Illinois, a southbound Wisconsin Central ore train rumbles by the old Soo Line depot at Lomira on 23 March 1996.

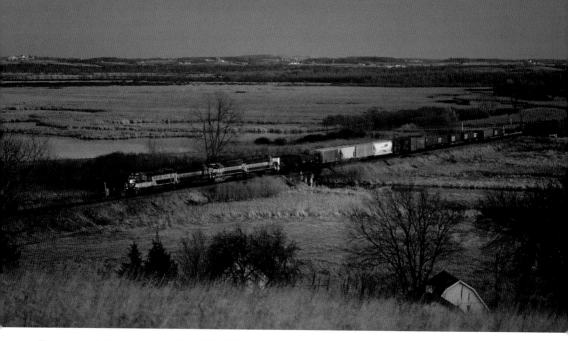

Five minutes before sunset on 5 April 1996, Wisconsin Central F45 No. 6653, along with a trio of SD45s, crosses the Rock River as it rolls train 49 through the marshlands at Theresa.

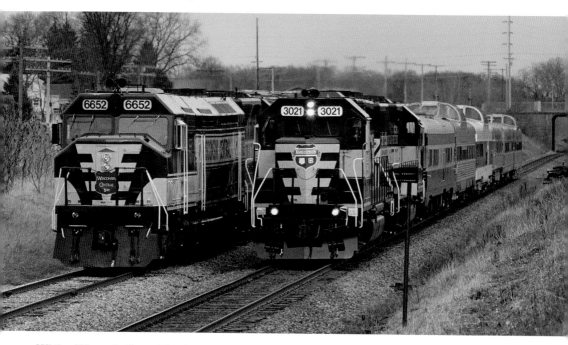

While a Wisconsin Central freight sits on the connection track to the old Green Bay & Western (acquired by WC in August 1993) at Amherst Junction, an extra passenger train rolls by on the WC main line on 2 May 1996. This special, called the Laird Express, operated from Waukesha to Marshfield to raise money for the Marshfield Clinic. Former U. S. Secretary of Defense (and strong supporter of medical research and heath) Melvin R. Laird and Olympic Gold Medal speed skater Dan Jansen were among the guests on the train. WC EMD GP40 Nos 3021 and 3017 carried special 'The Campaign Train for Science' lettering as well as unique 'Laird Express' nose emblems specially applied for the occasion.

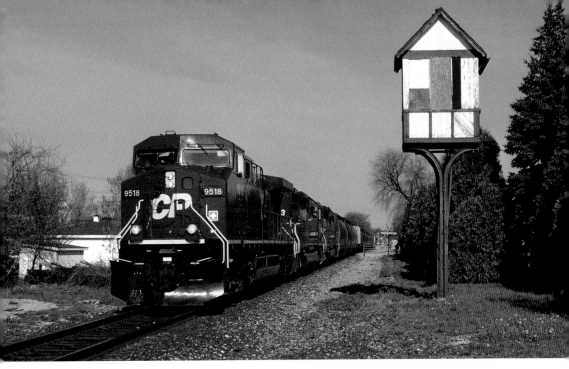

Canadian Pacific train 580 passes the abandoned elevated signal tower at Oconomowoc on the morning of 12 May 1996. The tower at one time controlled nearby grade crossing signals and gates on this once double-track former Milwaukee Road main line.

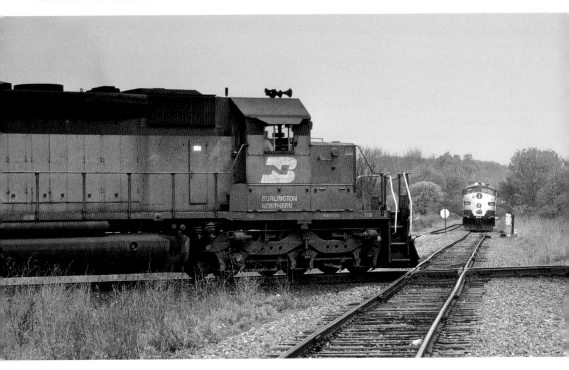

An eastbound Wisconsin & Southern passenger special waits patiently at the Crawford crossing just east of Prairie du Chien on 19 May 1996. A westbound Burlington Northern freight led by a commonplace EMD SD40-2 is about to pound the diamond.

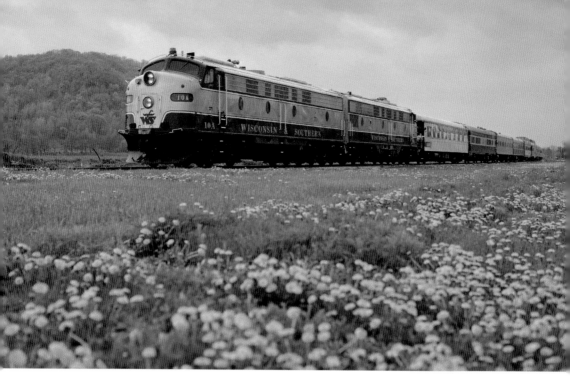

A Wisconsin & Southern passenger train passes a field of dandelions at Blue River on 19 May 1996. The special is running from Prairie du Chien east to Madison on this former Milwaukee Road line.

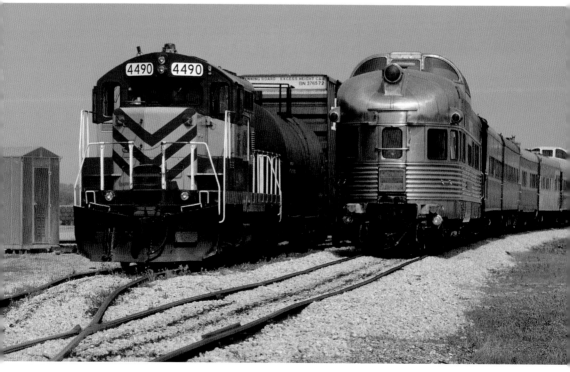

An eastbound Wisconsin & Southern passenger special has a former California Zephyr dome-observation car carrying the markers as it passes a WSOR local at Middleton, just west of Madison, on 19 May 1996.

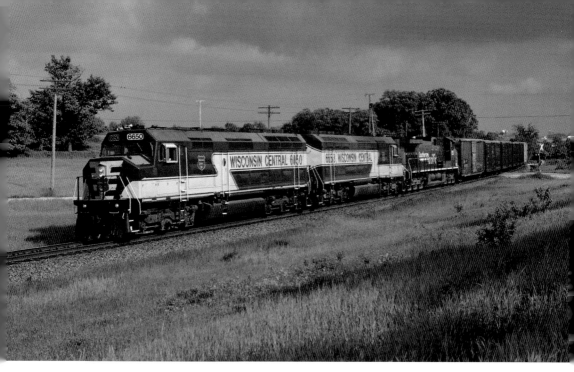

Wisconsin Central train 45 descends Byron Hill at Hamilton on the afternoon of 11 June 1996. Powering the westbound train that is nearing the crew change of North Fond du Lac is a pair of EMD F45 'cowls', Nos 6650 and 6653, along with a new Southern Pacific GE AC4400CW.

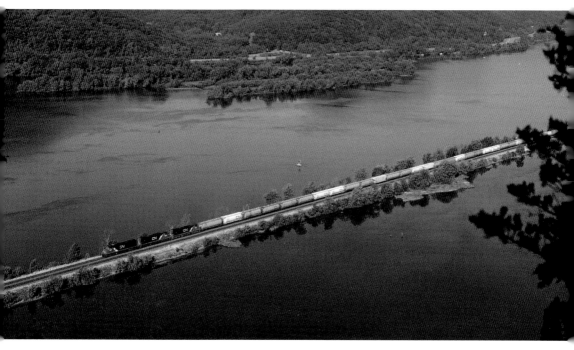

A climb up a tall bluff called Trempealeau Mountain just north of Trempealeau yields this vista of the Mississippi River valley and part of Burlington Northern's long causeway just east of Winona, Minnesota. On the morning of 15 June 1996, an eastbound Canadian National train, powered by a trio of EMD SD70I locomotives, slices its way over the impressive route on the Wisconsin side of the river.

Burlington Northern Santa Fe train 144 hustles past the Trempealeau Marina along the Mississippi River on 15 June 1996. Almost looking like a BN train, the Santa Fe EMD GP9r No. 2258 in the consist is a sign of things to come. The union between BN and Santa Fe was made official by the formation of a holding company on 22 September 1995, but the two railroads didn't formally merge until 31 December 1996.

Wisconsin Central's ANPRA train heads southbound out of Fond du Lac on 20 July 1996. The Chicago-bound train is traveling on WC's Fox Valley & Western, the former Fox River Valley Railroad (FRVR), formed from cast-off Chicago & North Western routes in Wisconsin. The train is passing milepost 147, and is crossing Morris Street and North 12th Street grade crossings, protected by an animated quartet of wig-wags!

Wisconsin Central train 46 heads southbound through rolling Wisconsin farmland at Theresa on the morning of 20 July 1996. That state's highway 28 rises over the hill above the pair of shiny WC EMD SD45s.

At the end of a cold 7 December 1996 day, Wisconsin Central train 47 diverges onto the connection track at Duplainville for the trip back home to North Fond du Lac. Train Nos 46 and 47 were a turn, operating from North Fond du Lac to Muskego Yard in Milwaukee and return. Today's train is led by WC's only EMD FP45, No. 6652.

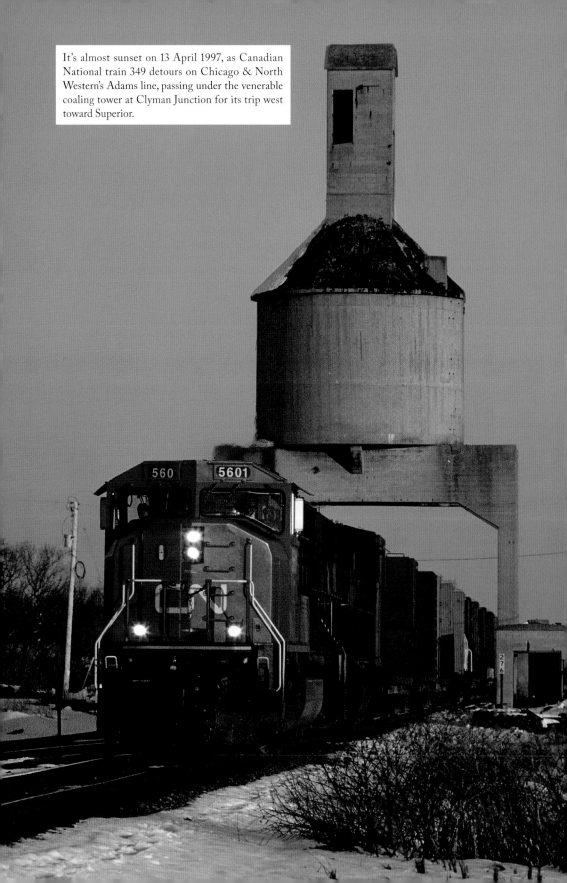

It's almost sunset on 13 April 1997, as Canadian National train 349 detours on Chicago & North Western's Adams line, passing under the venerable coaling tower at Clyman Junction for its trip west toward Superior.

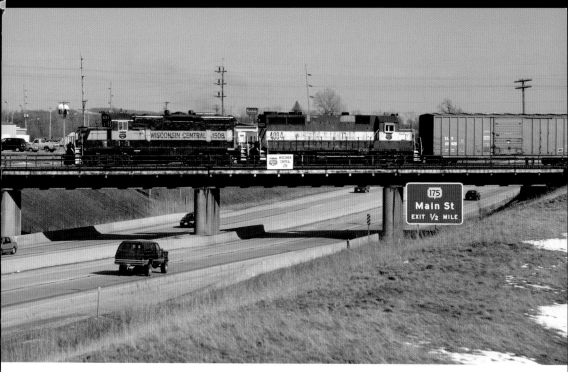

Crossing a bridge over Highway 45, a Wisconsin Central local switches at Valley, on the south side of Fond du Lac, on the afternoon of 14 April 1997. WC EMD GP7 No. 1508 is a former Algoma Central locomotive.

Wisconsin Central train 51 thunders over the crossing with Wisconsin & Southern at Slinger on the afternoon of 14 April 1997. The structure on the right advertises locally famous Storck Brewery. Built in 1868 in Schleisingersville (later shortened to Slinger … thank goodness), the brewery finally closed in 1958. Most of the brewery complex was torn down in the following years, except the lone surviving structure, the kegging house seen in this photo. Interestingly, during the U.S. prohibition era from 1920 to 1933, Storck officially made ice cream, but still produced beer on the sly.

A southbound Wisconsin Central coal train passes by the Don Bechler & Sons dairy farm just south of Van Dyne on the afternoon of 14 April 1997.

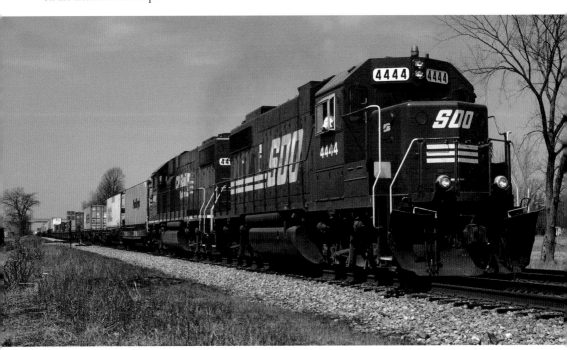

An eastbound Soo Line intermodal train zips through Duplainville, led by a locomotive with a lot of fours – Soo Line EMD GP38-2 No. 4444. In 1990, Canadian Pacific gained full control of Soo Line and began slowly integrating the railroad, as can be seen by trailing former Soo GP38-2 No. 4406, in the then-current CP Rail 'Duel Flags' scheme.

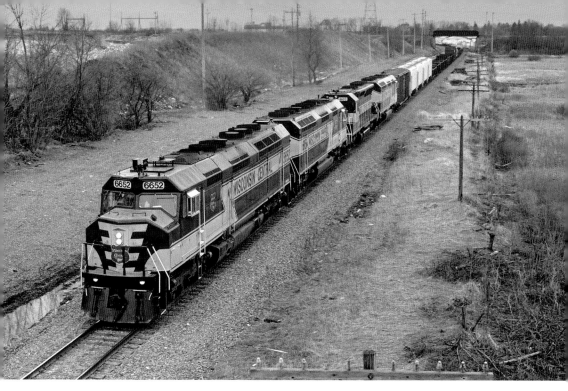

Wisconsin Central train 51 passes underneath the Chicago & North Western's Adams Line at Sussex on 16 April 1997. On the point is WC's only EMD FP45, No. 6652, followed by an SD45 sandwiched by two F45s.

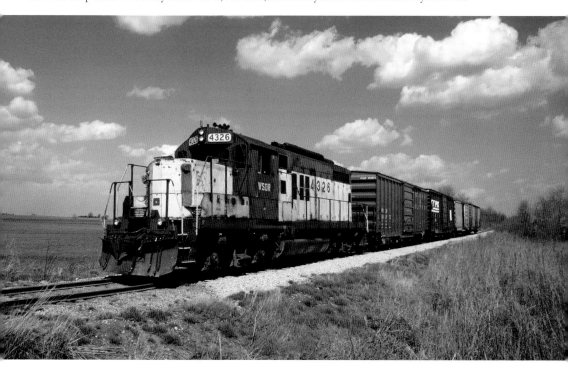

A short Wisconsin & Southern train heads west at Randolph on 5 May 1997. Powering the four-car train on the railroad's Horicon to Cambria line is WSOR No. 4326, a former Chicago & North Western EMD GP7 still in yellow and green paint.

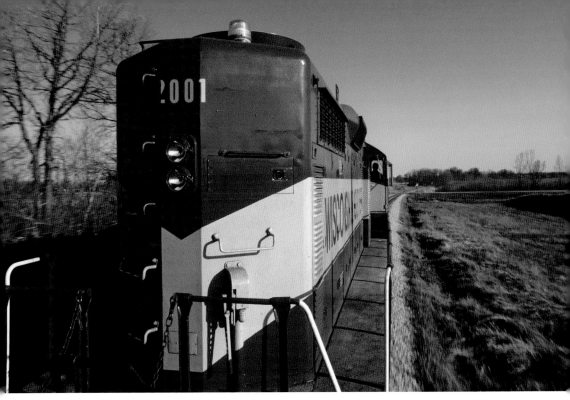

Wisconsin & Southern EMD GP20 No. 2001 rolls through the Wisconsin countryside north of Burnett on the WSOR's Horicon to Oshkosh line on 6 May 1997.

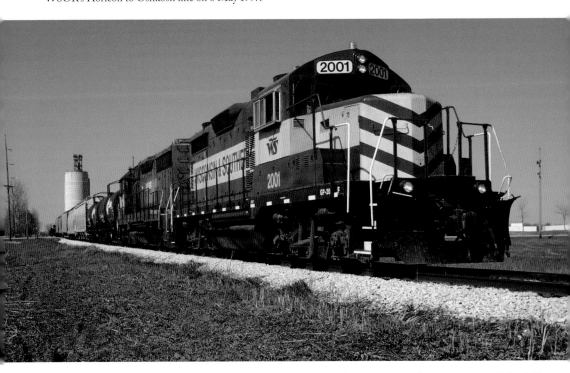

Wisconsin & Southern's freight between Horicon and Oshkosh switches customers at Ripon on a sunny 6 May 1997. Shiny WSOR No. 2001 is a former Cotton Belt EMD GP20 built in January 1961 and originally numbered 802.

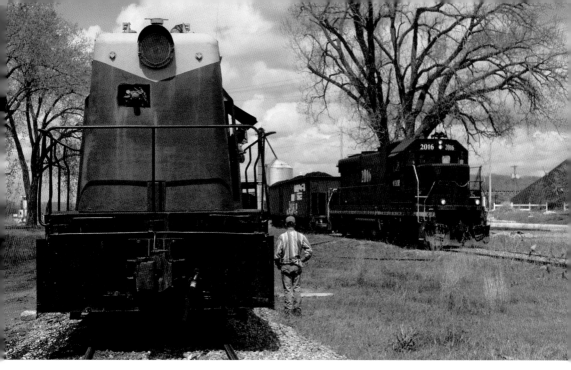

Coal for University of Wisconsin-Madison's power plant arrived via barge on the Mississippi River at Prairie du Chien. It then was switched by this old Whitcomb locomotive, and picked up by a Wisconsin & Southern train. On 8 May 1997, the crew of the Whitcomb stands by as WSOR No. 2016 fetches a string of loaded coal hoppers bound for Madison. The Whitcomb was built for the U.S. Army in 1943 as No. 7970. It was sold to Material Services, then went to Pillsbury in 1978, before becoming a numberless Prairie Sand & Gravel Co. locomotive, finally working coal hoppers at Prairie du Chien.

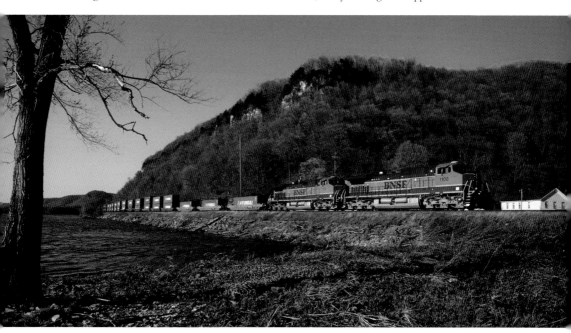

An eastbound Burlington Northern Santa Fe intermodal train speeds along the bank of the Mississippi River through Glen Haven on the afternoon of 9 May 1997. A pair of BNSF's new GE C44-9Ws in Heritage I colors powers the Chicago-bound train.

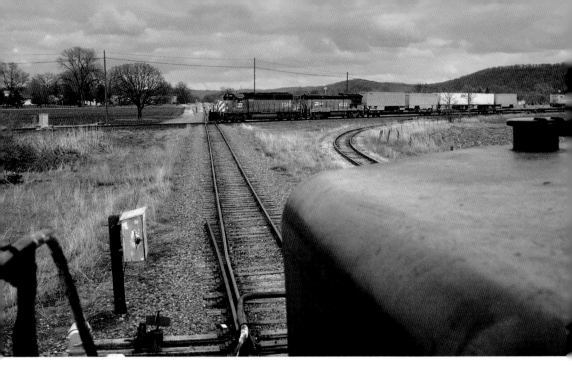

A view from the cab of Wisconsin & Southern EMD SD20 No. 2016 on an eastbound freight, waiting at the derail for permission to cross the busy Burlington Northern Santa Fe main line, sees a westbound BNSF 'Expediter' intermodal train about to pound the crossing at Crawford, south of Prairie du Chien, on 8 May 1997.

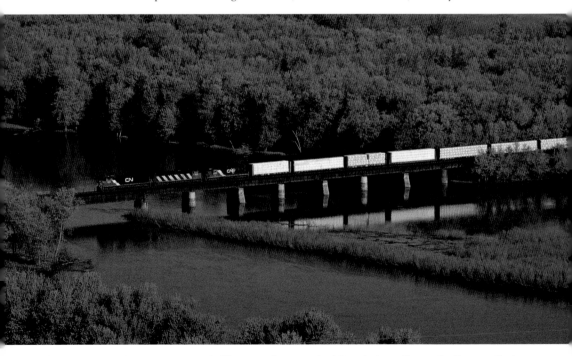

Canadian National train 340 crosses the Wisconsin River south of Crawford near Prairie du Chien on Burlington Northern Santa Fe's former BN main line along the Mississippi River between La Crosse and Savanna, Illinois, on the morning of 17 May 1997. CN used BN/BNSF trackage rights from Superior to reach Chicago until acquiring Wisconsin Central in 2001.

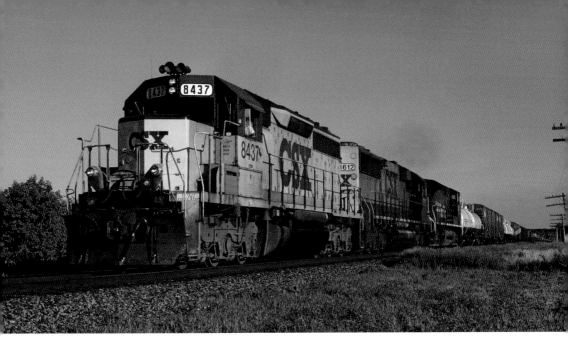

A Wisconsin Central freight, powered by a pair of CSX EMD locomotives and a Southern Pacific GE AC4400CW, passes milepost 105 between Duplainville and Sussex on the afternoon of 17 July 1997. You never knew what railroad's locomotives you'd see running on the WC in this era.

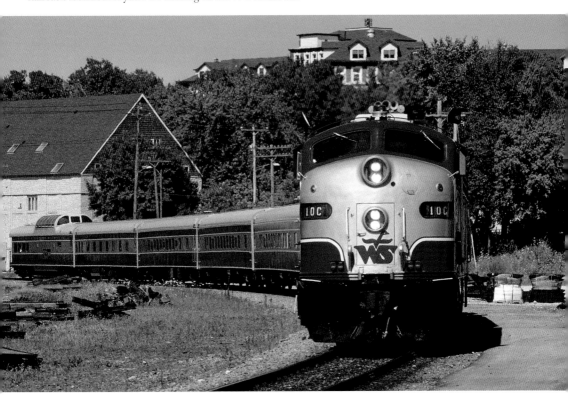

A Wisconsin & Southern inspection train heads south through Waukesha on 29 July 1997. The classy train is using Wisconsin Central trackage rights to travel from Rugby Junction to Grand Avenue in Waukesha, where the train will once again be on home rails toward Janesville.

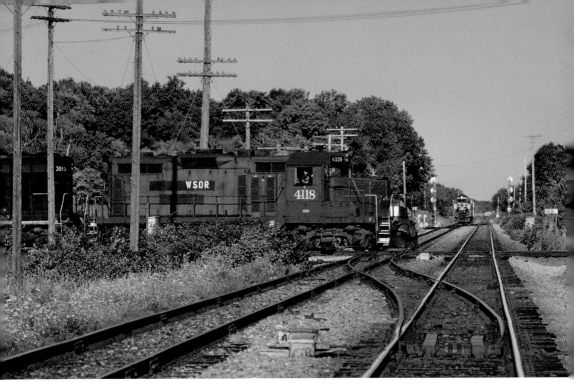

A southbound Wisconsin & Southern freight, led by former Southern Pacific EMD GP20 No. 4118, is about to thunder over the diamond at Duplainville on the afternoon of 29 July 1997. On the Soo Line's former Milwaukee Road double-track main line is Wisconsin Central train 47, waiting at the connection track signal to head north on the WC main after the WSOR train clears the plant.

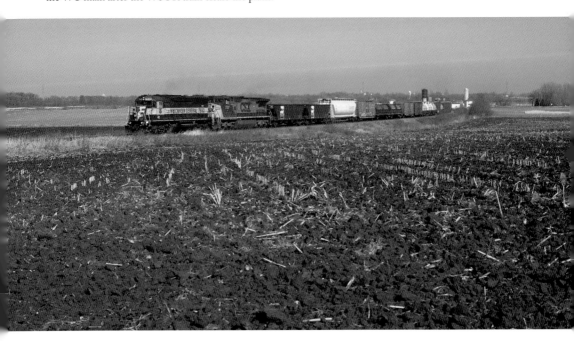

By the date of this photo on 12 November 2001, Canadian National completed the purchase of Wisconsin Central. A southbound freight, still looking like WC, climbs Byron Hill at Lost Arrow Road south of Fond du Lac at Valley, led by WC EMD SD45 No. 7592.

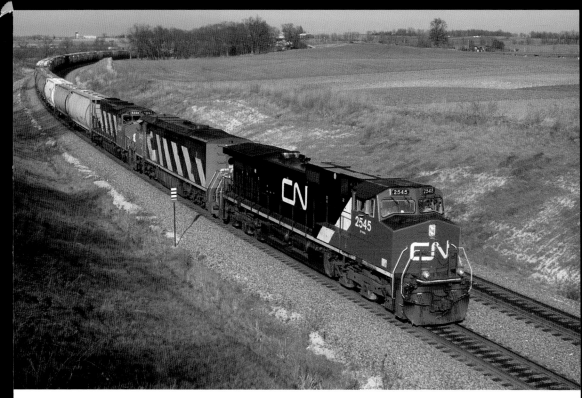

A little later on the morning of 12 November 2001, a southbound Canadian National freight is approaching the top of Byron Hill at Bryon. The main line up the grade from Valley to Bryon has recently been double-tracked as seen in this view.

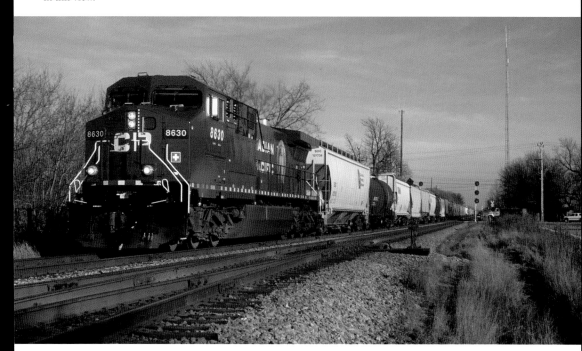

In the 2000s, the Soo Line Railroad and image was gradually absorbed into parent Canadian Pacific. On the afternoon of 12 November 2001, a Canadian Pacific freight pulled by lone CP GE AC4400CW No. 8630 rumbles westbound through Duplainville.

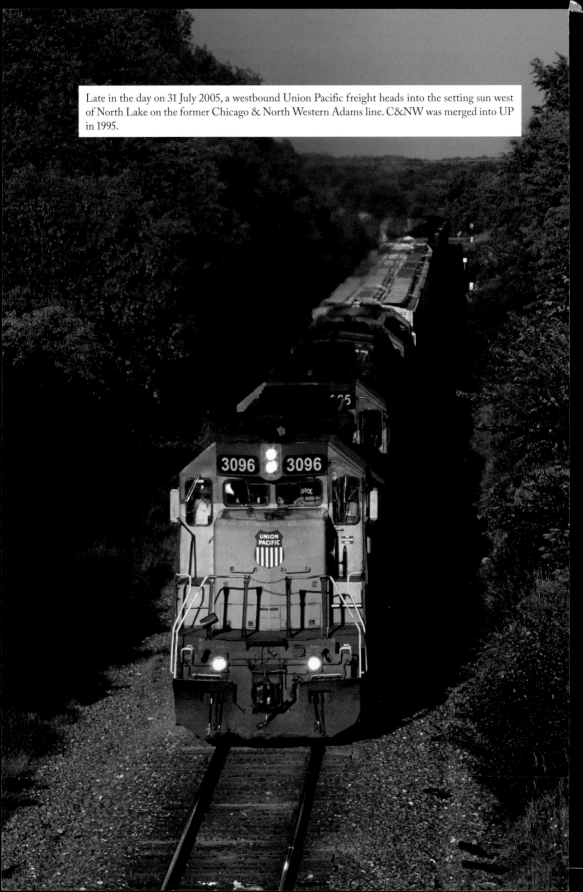

Late in the day on 31 July 2005, a westbound Union Pacific freight heads into the setting sun west of North Lake on the former Chicago & North Western Adams line. C&NW was merged into UP in 1995.